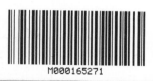

Cool Restaurants Prague

teNeues

Imprint

Editor:	Sabina Marreiros
Photos (location):	Markus Bachmann (Arzenal, Barock Restaurant and Lounge Bar, Café Bogner, Café La Veranda, Divinis, HOT Restaurant, Kolkovna, Lacerta, La Perle de Prague, Lary Fary, Pravda Restaurant, Resto Café Patio, Šípek Bistrot, Terasa U Zlaté studně, Tretter's New York Bar, VINOdiVINO) Courtesy Hotel Josef (Hotel Josef Bar), Courtesy Kampa Group (Bazaar Restaurant, Hergetova Cihelna, Kampa Park, Square), Courtesy Bacchusgroup (Barock Restaurant and Lounge Bar, HOT Restaurant, Pravda Restaurant), Courtesy Café La Veranda (Café La Veranda), Courtesy Kolkovna Group (Bella Vista Prague, Lary Fary, Kolkovna), Courtesy PATRIOT-X (PATRIOT-X), Courtesy Šípek Bistrot (Šípek Bistrot), Filip Šlapal (Holport Café, Zahrada v opeře)
Coverphoto:	Filip Šlapal
Introduction:	Heinfried Tacke
Layout & Pre-press:	Thomas Hausberg
Imaging:	Jan Hausberg
Translations:	SAW Communications, Dr. Sabine A. Werner, Mainz Dr. Suzanne Kirkbright (English), Céline Verschelde (French) Silvia Gómez de Antonio (Spanish), Elena Nobilini (Italian) Nina Hausberg (German, English / recipes)

Produced by fusion publishing GmbH / Stuttgart . Los Angeles
www.fusion-publishing.com

Published by teNeues Publishing Group

teNeues Publishing Company
16 West 22nd Street, New York, NY 10010, USA
Tel.: 001-212-627-9090, Fax: 001-212-627-9511

teNeues Book Division
Kaistraße 18, 40221 Düsseldorf, Germany
Tel.: 0049-(0)211-994597-0, Fax: 0049-(0)211-994597-40

teNeues Publishing UK Ltd.
P.O. Box 402, West Byfleet, KT14 7ZF, Great Britain
Tel.: 0044-1932-403509, Fax: 0044-1932-403514

teNeues France S.A.R.L.
4, rue de Valence, 75005 Paris, France
Tel.: 0033-1-55766205, Fax: 0033-1-55766419

teNeues Iberica S.L.
Pso. Juan de la Encina, 2–48, Urb. Club de Campo
28700 S.S.R.R., Madrid, Spain
Tel./Fax: 0034-91-6595876

www.teneues.com

ISBN-10:	3-8327-9068-3
ISBN-13:	978-3-8327-9068-4

© 2005 teNeues Verlag GmbH + Co. KG, Kempen

Printed in Italy

Bibliographic information published by Die Deutsche Bibliothek.
Die Deutsche Bibliothek lists this publication in the Deutsche Nationalbibliografie; detailed bibliographic data is available in the Internet at http://dnb.ddb.de.

Contents Page

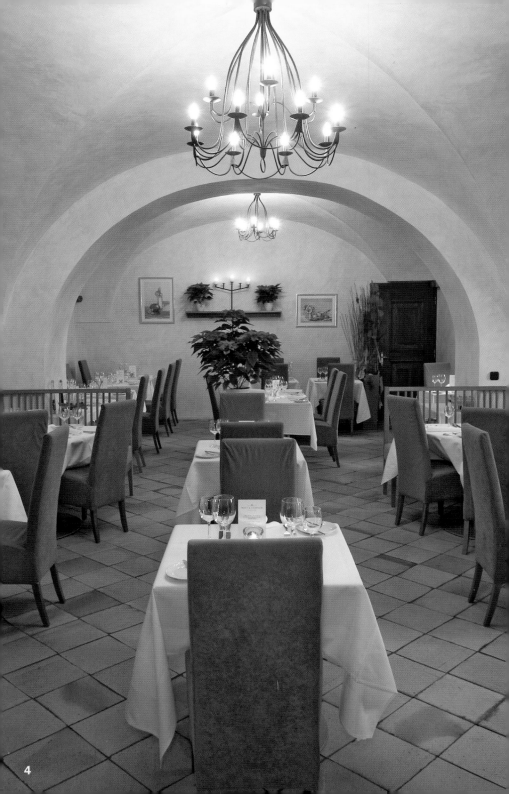

Introduction

When it's a question of lifestyle, Prague is among those eastern European cities to have profited most from the fall of the Iron Curtain. In the Czech metropolis, sophisticated life flourishes in a way that bears little resemblance to pre-1989 days. Only insiders will still remember the old addresses that already gave an inkling of the potential slumbering in this city. And maybe a few people still longingly think back to the story of "The Unbearable Lightness of Being", set in Milan Kundera's pre-revolutionary Prague and winning the popularity of millions as a book and a film.

Today, more than a decade after the transformation in politics and the economy, the city is bursting with international flair. But Prague has lost nothing of its old charm with the historic façades and spots like the Prague Castle, the Jewish Joseph's Quarter, Wenceslas Square and the famous Charles Bridge over the Vltava river. But this historical backdrop has been freshened up with a bright new scene: fashion gurus, designers, the film world and other artists treat this as their playground and mingle with a wealthy business clientele with money to spend. Together, they are an inspiring force behind a new culture of restaurants, bars and cafés that are totally on a par with western standards and nearly every cuisine and culinary style from around the world is represented. This includes, for example, the restaurant "Barock" or even the design hotel "Josef" with its bar and restaurant of the same name. Anyone who wants to see what's new in 21st Century Europe cannot miss out on a trip to the trendsetting city of Prague.

The guide gives an exclusive cross-section of all those addresses that represent the new avant-garde. They not only introduce a picture of a new, young Prague, but they also provide a brief survey of the route for these new trends. The guide interests both experts in the fields of architecture, design or gastronomy or simply all those readers who want to get a piece of the action and try out Prague's fashionable bars and cafés. Maybe you will all react to this adventure in the same way as the authors did: we were simply raving about it!

Heinfried Tacke

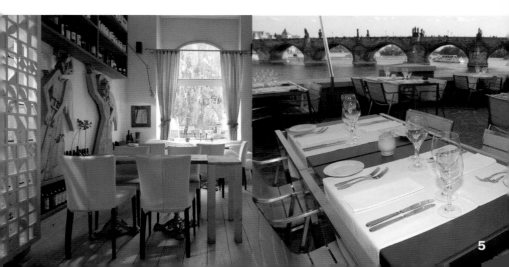

Einleitung

In Sachen Lifestyle gehört Prag zu den Städten in Osteuropa, die am meisten vom Fall des eisernen Vorhangs profitiert haben. In der tschechischen Metropole blüht ein mondänes Leben, nicht mehr zu vergleichen mit den Jahren vor 1989. Nur Insider werden sich noch an die Adressen von damals erinnern, die schon zu jener Zeit erahnen ließen, welch Potential in dieser Stadt schlummert. Und vielleicht denkt der ein oder andere auch noch wehmütig an die Geschichte von der unerträglichen Leichtigkeit des Seins zurück, die bei Milan Kundera im Prag der Vorwende spielt und die als Buch wie als Film ein Millionenpublikum begeisterte. Heute, mehr als eine Dekade nach dem einschneidenden Wechsel in Politik und Wirtschaft, strotzt die Stadt nur so vor Internationalität. Dabei hat Prag nichts von seinem alten Charme eingebüßt mit den historischen Fassaden und Orten wie der Hofburg, dem jüdischen Josefsviertel, dem Wenzelplatz und der berühmten Karlsbrücke über die Moldau. Doch zu dieser geschichtsträchtigen Kulisse ist eine quicklebendige Szene hinzugekommen: Modeschöpfer, Designer, Filmleute und andere Kreative tummeln sich hier und vermengen sich mit einer kaufkräftigen Schicht aus der Geschäftswelt. Sie zusammen sind die Schubkräfte für eine neue Kultur an Restaurants, Bars und Cafés, die sich ganz und gar auf westlichem Level bewegt und fast alle Küchen und Stile der Welt widerspiegelt. Dazu gehören beispielsweise das Restaurant „Barock" oder etwa das Designhotel „Josef" mit seiner Bar und dem gleichnamigen Restaurant. Wer die Entwicklungen im Europa des 21. Jahrhunderts beobachten will, der kommt an Prag als Trendsetter nicht länger vorbei.

Das Buch gibt einen exklusiven Querschnitt jener Adressen, die für diese Avantgarde stehen. Sie vermitteln nicht nur ein Bild vom neuen, jungen Prag, sondern sind zugleich eine kleine Studie darüber, wohin die Reise der Trends geht. Branchenfachleute aus Architektur, Design oder Gastronomie finden darin ebenso einen Leitfaden wie all diejenigen, die einfach nur auf der Prager Szenepiste unterwegs sein wollen. Vielleicht wird es ihnen allen bei dieser Stöbertour ähnlich ergehen wie den Autoren: Wir waren schlicht begeistert.

Heinfried Tacke

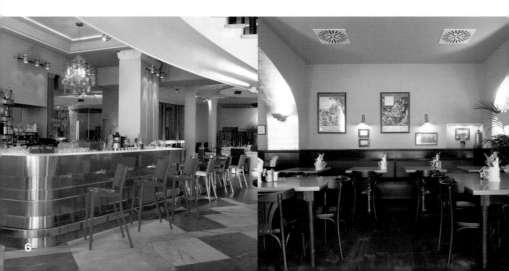

Introduction

En matière d'art de vivre, Prague fait partie des villes d'Europe de l'Est qui ont le plus profité de la chute du rideau de fer. Dans la métropole tchèque se développe une vie mondaine incomparable à la vie des années antérieures à 1989. Seuls les initiés se souviennent encore des adresses d'autrefois qui laissaient déjà deviner à cette époque le potentiel qui sommeillait dans cette ville. Il est possible que quelqu'un repense encore avec mélancolie à l'histoire de « L'Insoutenable légèreté de l'être » que Milan Kundera a situé à Prague au cours de la période précédant la chute du bloc de l'Est et dont le livre, tout comme le film, passionna des millions de personnes.

Aujourd'hui, plus d'une décennie après une changement décisif sur le plan politique et économique, la ville déborde d'internationalité. Mais Prague n'a rien perdu de son ancien charme avec ses façades historiques et des lieux comme le palais de la Hofburg, le quartier juif Josefov, la place Venceslas et le célèbre pont Charles enjambant la Moldau. Une scène trépidante est toutefois venue se greffer à cette coulisse historique : créateurs de mode, designers, cinéastes et autres créateurs se rassemblent ici et se mélangent à une couche aisée du monde des affaires. Ensemble, ils sont les moteurs d'une nouvelle culture de restaurants, de bars et de cafés qui gravite à un niveau occidental et reflète presque toutes les cuisines et tous les styles du monde. En font partie par exemple le restaurant « Barock » ou encore l'hôtel design « Josef » avec son bar et le restaurant du même nom. Celui qui souhaite observer les évolutions se manifestant en Europe au 21ème siècle ne passera pas plus longtemps à coté de Prague, véritable figure de proue.

Ce livre offre une coupe transversale exclusive des adresses symboliques de cette avant-garde. Elles transmettent non seulement une image de la ville de Prague jeune et récente, mais elles sont également une petite étude sur l'évolution des tendances. Les spécialistes des branches telles que l'architecture, le design ou la gastronomie y trouvent un fil conducteur, tout comme tous ceux qui souhaitent seulement se promener dans les quartiers branchés de Prague. Peut-être connaî-tront-ils tous la même sensation qu'ont eu les auteurs en flânant : ils sont tout simplement tombés sous le charme.

Heinfried Tacke

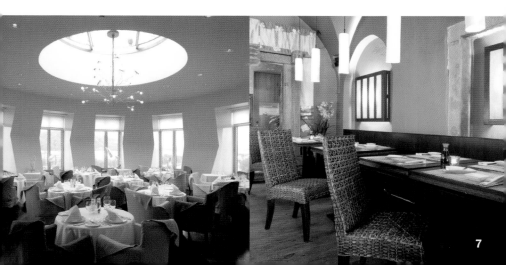

Introducción

En lo referente al estilo de vida, Praga pertenece a las ciudades de la Europa Oriental que más se han beneficiado de la desaparición del telón de acero. En esta ciudad checa florece una vida mundana que no se puede comparar con la de los años anteriores a 1989. Sólo los verdaderamente entendidos podrán acordarse todavía de aquellas direcciones que ya entonces dejaban entrever el potencial que dormitaba en la ciudad. Y quizás alguna que otra persona evoque aún con melancolía la historia de "La insoportable levedad del ser", la obra de Milan Kundera ambientada en la Praga anterior al cambio y que entusiasmó a millones de lectores y de espectadores.

Hoy, más de una década después del radical cambio experimentado en la política y la economía, Praga rebosa internacionalidad. Esta transformación, sin embargo, no ha supuesto la pérdida de su antiguo encanto, con sus fachadas históricas y lugares como el Palacio Imperial, la Wenzelplatz, el antiguo barrio judío Josef y el famoso Puente de Carlos sobre el río Moldova. Pero a estos escenarios históricos se le ha añadido un nuevo y activo círculo social: creadores de moda, diseñadores, cineastas y otros artistas se reúnen aquí y se mezclan con una capa social de gente de negocios con un fuerte poder adquisitivo. Juntos constituyen la fuerza de empuje de una nueva cultura de restaurantes, bares y cafés de igual nivel que los occidentales y donde se reflejan la gastronomía y los estilos de todo el mundo.

Entre estos locales encontramos, por ejemplo, el restaurante "Barock" o el hotel de diseño "Josef", con un bar y un restaurante con el mismo nombre. Quien quiera observar la evolución de la Europa del siglo XXI deberá visitar obligadamente Praga como ciudad creadora de tendencias.

Este libro ofrece una exquisita muestra de los lugares representativos de esta vanguardia. Los locales no sólo transmiten una imagen de la nueva y joven Praga, sino que, además, son un pequeño estudio sobre la dirección de las tendencias. Profesionales de la arquitectura, del diseño o de la gastronomía encontrarán en estas páginas una guía orientativa, al igual que todos aquellos que simplemente quieran recorrer y conocer la escena de Praga. Y quizá a todos los que realicen este viaje de descubrimientos les suceda lo mismo que a los autores: Nos fascinó.

Heinfried Tacke

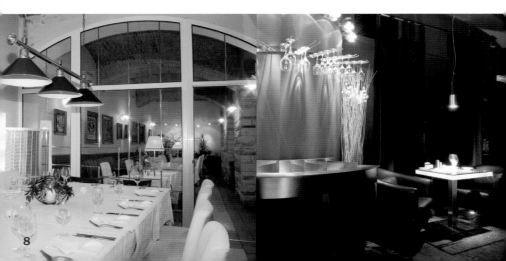

Introduzione

In fatto di stile di vita Praga è una di quelle città dell'Europa dell'Est che più di altre ha tratto profitto dalla caduta della cortina di ferro. Nella metropoli ceca sta prosperando una vita mondana che non ha più nulla a che vedere con gli anni precedenti il 1989. Solo gli insider forse si ricorderanno ancora degli indirizzi di quei tempi che già allora facevano intuire che potenziale nascondesse questa città. E forse qualcuno sta ancora malinconicamente pensando alla storia dell'insostenibile leggerezza dell'essere, che Milan Kundera ambientò nella Praga del periodo precedente alla svolta e che ha entusiasmato, sia come libro che come film, milioni di persone.

Oggi, ad oltre un decennio dal radicale cambiamento nel panorama politico ed economico, questa città sprizza internazionalità da tutti i pori; senza perdere però il suo vecchio fascino, fatto di facciate storiche e luoghi come per esempio l'Hofburg, il quartiere ebraico Josefov, la Piazza Wenzel e il famoso Ponte Carlo sulla Moldava. Su questo palcoscenico così carico di storia è andata ad aggiungersi ora una scena estremamente viva: stilisti, designer, gente del cinema ed altri estrosi scorrazzano in questa città, mescolandosi ad una classe del mondo degli affari con grande potere d'acquisto. Insieme costituiscono la spinta verso una nuova cultura di ristoranti, bar e caffè a livello completamente occidentale che riflette tutte le cucine e tutti gli stili del mondo. Fanno parte, ad esempio, di questa cultura il ristorante "Barock" o il design hotel "Josef", con il suo bar e l'omonimo ristorante. Chi desidera osservare da vicino gli sviluppi dell'Europa del XXI secolo, non potrà più fare a meno di visitare questa Praga precorritrice di tendenze.

Il libro contiene una rassegna esclusiva degli indirizzi rappresentativi di questa avanguardia, che permettono non solo di farsi un'idea della nuova e giovane Praga, ma che rappresentano, al contempo, un breve studio sul percorso seguito dalle tendenze. Una guida rivolta ad esperti di diverse branche, quali architettura, design o gastronomia, ma anche a tutti coloro che desiderano semplicemente godersi la vita notturna praghese. Forse anche loro, nello scovare posti nuovi, proveranno la stessa cosa che abbiamo provato noi autori: entusiasmo puro.

Heinfried Tacke

Arzenal

Design: Bořek Šípek | Chef: Nathaya Kaewphoopha
Owner: Bořek Šípek

Valentinská 11/56 | 110 00 Prague | Prague 1
Phone: +420 224 814 099
www.arzenal.cz | restaurace@arzenal.cz
Subway: Staroměstská
Opening hours: Every day 10 am to 11 pm
Average price: Czk 250
Cuisine: Thai style
Special features: Thai service

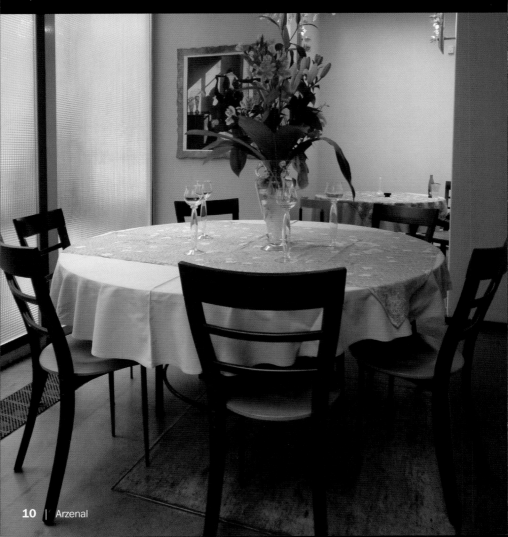

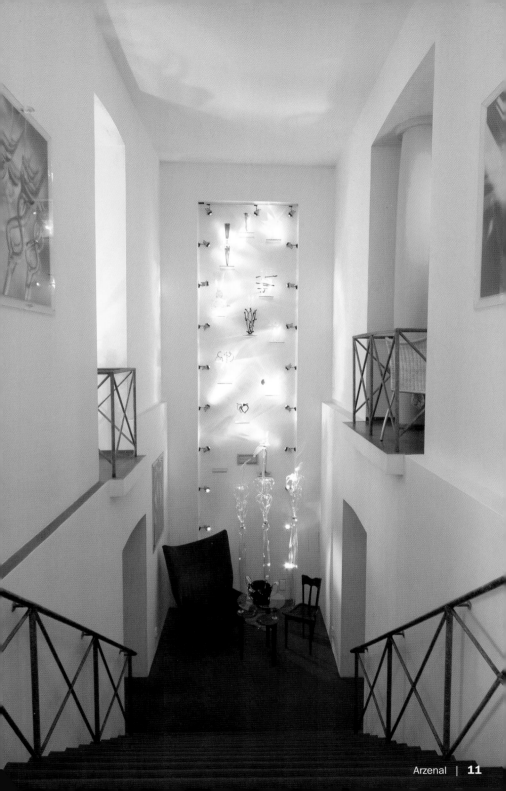

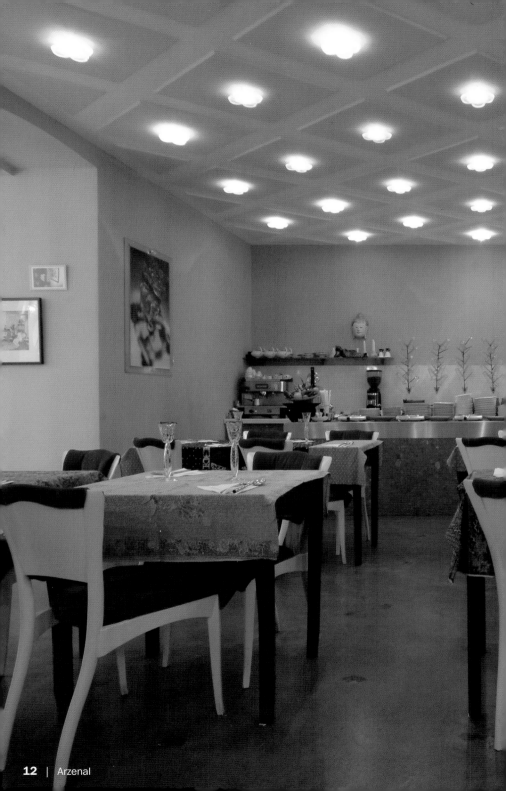

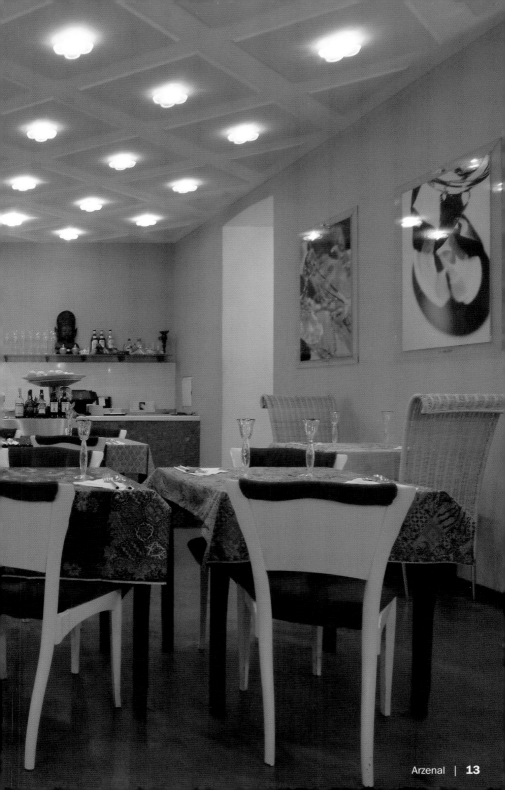

Pla Sardin Pad Pik Gang

2 lb sardines
Oil for deep-frying

3 tbsp sesame oil
4 tbsp red curry paste
120 ml chicken stock
4 tbsp fish sauce
4 lime leaves, whole
4 chilis, cut in rings
4 tbsp basil, chopped
Salt, sugar and pepper
Lettuce and basil leaves for decoration

Deep-fry fish for approx. 5 minutes. Remove and pat dry. Heat the sesame oil in a wok and sauté the curry paste. Add sardines, chicken stock, fish sauce and herbs. Cook for about 5 minutes, and then season to taste.

Serve with salad and basil leaves.

1 kg Sardinen
Öl zum Frittieren

3 EL Sesamöl
4 EL rote Currypaste
120 ml Geflügelbrühe
4 EL Fischsauce
4 Limettenblätter, ganz
4 Chilischoten, in Ringe
4 EL Basilikum, gehackt
Salz, Zucker und Pfeffer
Salat und Basilikumblätter zum Dekorieren

Den Fisch für ca. 5 Minuten frittieren. Herausnehmen und trockentupfen. Das Sesamöl in einem Wok erhitzen und die Currypaste anschwitzen. Die Sardinen, Geflügelbrühe, Fischsauce und Kräuter dazugeben. Für ca. 5 Minuten kochen, dann nach Geschmack würzen.

Mit Salat und Basilikumblättern servieren.

1 kg de sardines
Huile à frire

3 c. à soupe d'huile de sésame
4 c. à soupe de pâte de curry rouge
120 ml de bouillon de volaille
4 c. à soupe de sauce à poisson
4 feuilles de citron vert, entières
4 piments, en anneaux
4 c. à soupe de basilic, haché
Sel, sucre et poivre
Salade et feuilles de basilic pour la décoration

Faire frire le poisson pendant 5 minutes environ. Le retirer et l'essuyer. Faire chauffer l'huile de sésame dans un wok et faire suer la pâte de curry rouge. Y ajouter les sardines, le bouillon de volaille, la sauce à poisson et les herbes. Cuire pendant environ 5 minutes, puis épicer selon le goût.

Servir avec de la salade et des feuilles de basilic.

1 kg de sardinas
Aceite para freír

3 cucharadas de aceite de sésamo
4 cucharadas de pasta de curry roja
120 ml de caldo de ave
4 cucharadas de salsa de pescado
4 hojas de lima, enteras
4 guindillas, en aros
4 cucharadas de albahaca, picada
Sal, azúcar y pimienta
Lechuga y hojas de albahaca para decorar

Fría el pescado durante 5 minutos aproximadamente. Saque las sardinas y séquelas con un papel de cocina. Caliente el aceite de sésamo en un wok y rehogue la pasta de curry. Incorpore las sardinas, el caldo de ave, la salsa de pescado y las hierbas. Cueza durante 5 minutos aproximadamente y condimente al gusto.

Sirva con lechuga y hojas de albahaca.

1 kg di sardine
Olio per friggere

3 cucchiai di olio di sesamo
4 cucchiai di pasta di curry rossa
120 ml di brodo di pollo
4 cucchiai di salsa di pesce
4 foglie di limetta intere
4 peperoncini tagliati ad anelli
4 cucchiai di basilico tritato
Sale, zucchero e pepe
Insalata e foglie di basilico per decorare

Friggete il pesce per ca. 5 minuti. Toglietelo e asciugatelo picchiettando con carta da cucina assorbente. Scaldate l'olio di sesamo in un wok e fatevi dorare la pasta di curry. Aggiungete le sardine, il brodo di pollo, la salsa di pesce e le erbe. Fate cuocere per ca. 5 minuti, insaporite quindi a piacere.

Servite con insalata e foglie di basilico.

Barock Restaurant and Lounge Bar

Chef: Jana Janatová | Owner: Tommy Sjöö

Pařížská 24 | 110 00 Prague | Prague 1
Phone: +420 222 329 221
www.barock.bacchusgroup.cz | office@bacchusgroup.cz
Subway: Staroměstská
Opening hours: Every day 9:30 am to 1 am
Average price: Czk 1500
Cuisine: International

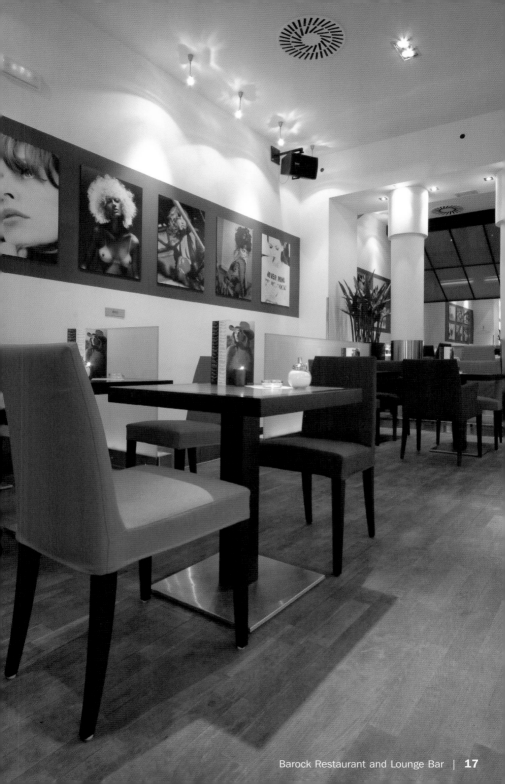

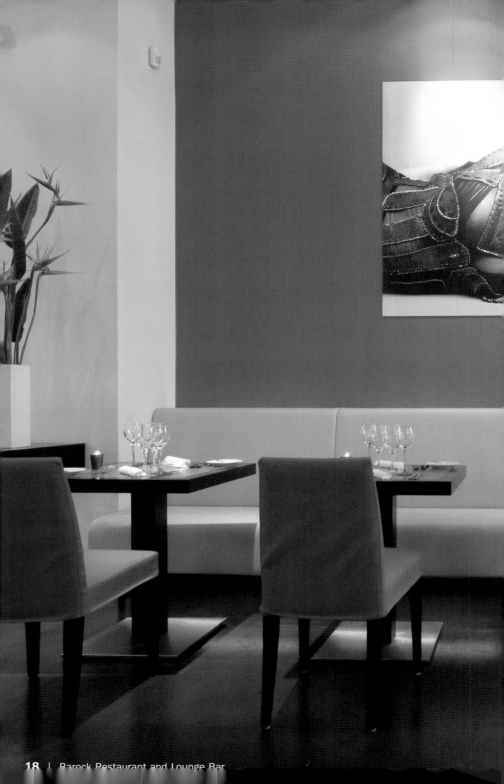

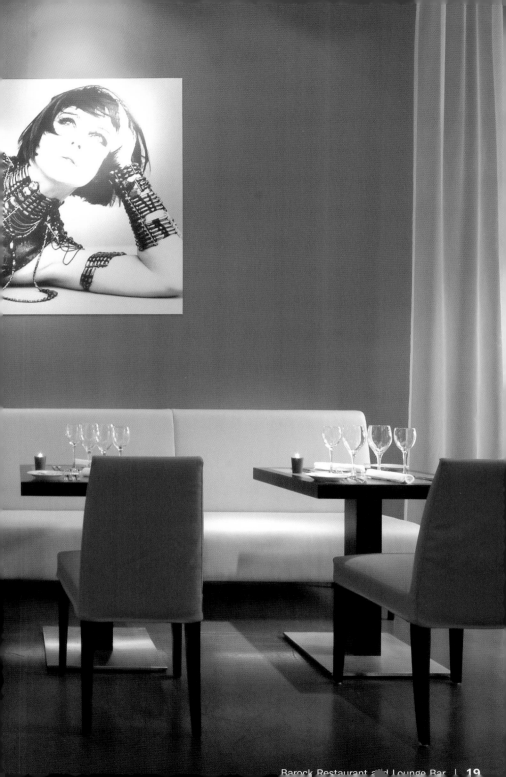

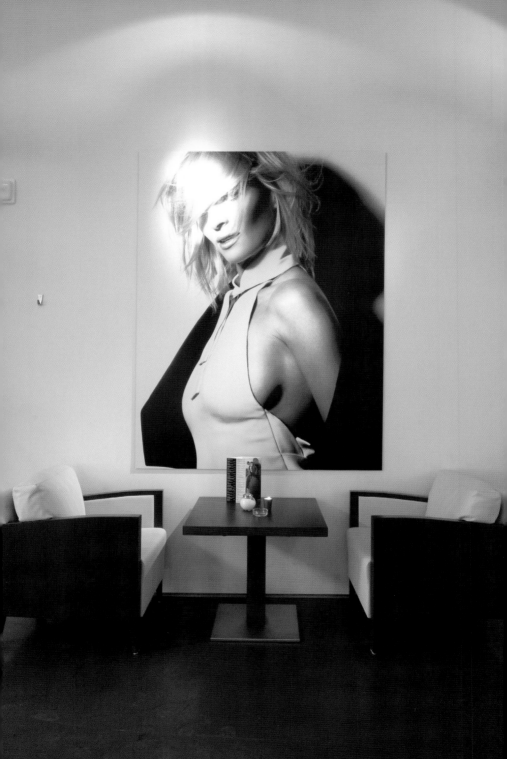

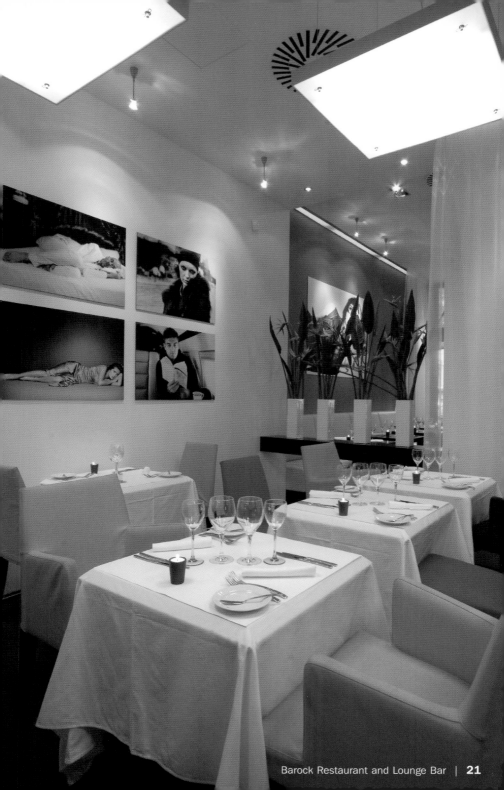

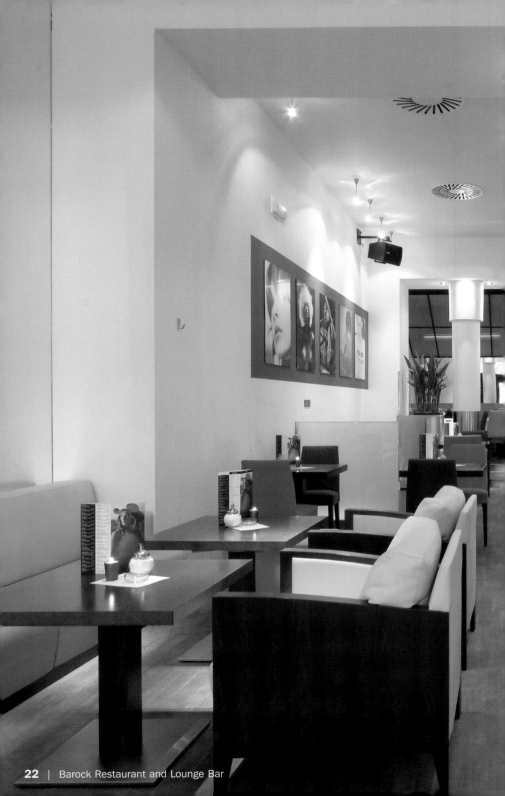

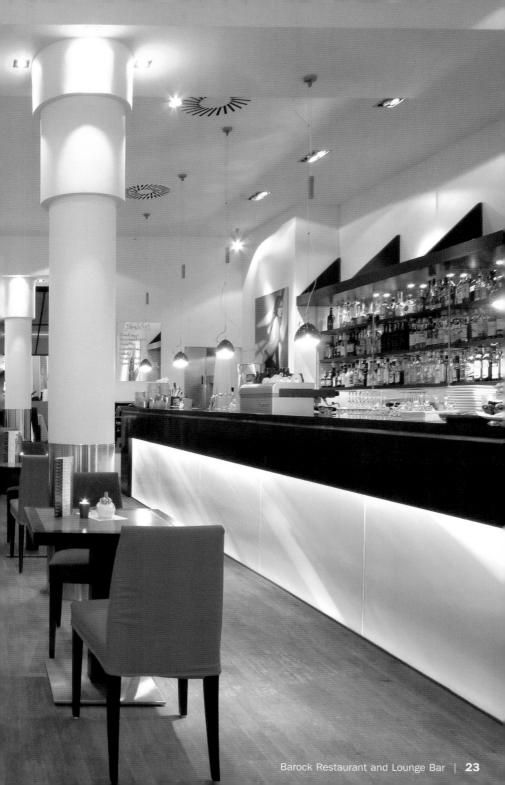

Pineapple and Coconut Sorbet
on Hazelnut-Nougat Crisp

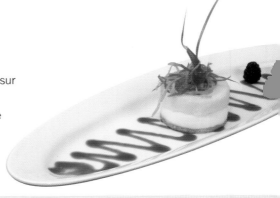

Ananas- und Kokosnuss-Sorbet auf
Haselnuss-Nougat-Crisps

Sorbet à l'ananas et à la noix de coco sur
crisps aux noisettes et au praliné

Sorbete de piña y coco sobre copos de
praliné y avellanas

Sorbetto di ananas e di noce di cocco
su scaglie di nocciola e di nougat

180 ml water
3 1/2 oz sugar
4 tbsp glucose
6 oz pineapple purée
180 ml coconut milk

Bring the water to boil, dissolve sugar and glucose and cook for 2 minutes. Divide into 2 bowls (plastic or metal), stir in the pineapple purée and coconut milk separately and freeze for at least 5 hours. Stir occasionally.

3 1/2 oz nougat
3 1/2 oz white chocolate
5 oz cornflakes, crushed
For decoration:
Orange and mint julienne, blackberries and raspberry sauce

Melt the nougat and chocolate over a pan of simmering water, stir in the cornflakes and pour onto a sheet of baking paper. Spread the mixture evenly and thinly and chill. Cut into circles, approx. 2 in. in diameter.

Spoon the pineapple and coconut sorbet in 2 layers on the nougat crisps and freeze immediately. Serve with orange and mint julienne, blackberries and raspberry sauce.

180 ml Wasser
100 g Zucker
4 EL Glukose
180 g Ananaspüree
180 ml Kokosnussmilch

Das Wasser aufkochen, den Zucker und die Glukose darin auflösen und 2 Minuten kochen. In zwei Schüsseln geben (Plastik oder Metall), Ananaspüree und Kokosnussmilch separat unterrühren und mindestens 5 Stunden einfrieren. Ab und zu umrühren.

100 g Nougat
100 g weiße Schokolade
150 g Cornflakes, zerbröselt
Als Dekoration:
Orangen- und Mintjulienne, Brombeeren und Himbeersauce

Nougat und Schokolade in einem Wasserbad schmelzen lassen, Cornflakes unterrühren und auf einen Bogen Backpapier geben. Gleichmäßig dünn aufstreichen und kühlen. Kreise von ca. 5 cm Durchmesser ausschneiden.

Das Ananas- und Kokosnuss-Sorbet in zwei Schichten auf den Nougat-Crisps verteilen und sofort einfrieren. Mit Orangen- und Mintjulienne, Brombeeren und Himbeersauce servieren.

180 ml d'eau
100 g de sucre
4 c. à soupe de glucose
180 g de purée d'ananas
180 ml de lait de coco

Faire bouillir l'eau, y dissoudre le sucre et le glucose et cuire pendant 2 minutes. Verser dans deux saladiers (en plastique ou en métal), incorporer séparément la purée d'ananas et le lait de noix de coco et congeler pendant au moins 5 heures. Remuer de temps en temps.

100 g de praliné
100 g de chocolat blanc
150 g de corn-flakes, émiettés
Pour la décoration :
Julienne d'orange et de menthe, des mûres et une sauce à la framboise

Faire fondre le praliné et le chocolat au bain-marie, y incorporer les corn-flakes et placer le tout sur un morceau de papier sulfurisé. Etaler uniformément de façon à obtenir une fine épaisseur et laisser refroidir. Découper des cercles de 5 cm de diamètre environ.

Répartir le sorbet à l'ananas et à la noix de coco en deux couches sur les crisps de praliné et congeler immédiatement. Servir avec une julienne d'orange et de menthe, des mûres et une sauce à la framboise.

180 ml de agua
100 g de azúcar
4 cucharadas de glucosa
180 g de puré de piña
180 ml de leche de coco

Lleve al agua a ebullición y derrita dentro el azúcar y la glucosa. Deje que hierva durante 2 minutos. Reparta la mezcla en dos cuencos (de plástico o metal). Mezcle por separado el puré de piña y la leche de coco en los cuencos e introdúzcalos en el congelador durante 5 horas como mínimo. Remueva de vez en cuando.

100 g de praliné
100 g de chocolate blanco
150 g de copos de maíz, desmenuzados
Para decorar:
Naranja y menta cortadas en juliana, zarzamora y salsa de frambuesa

Derrita el praliné y el chocolate al baño maría, añada los copos, remueva y ponga la mezcla sobre papel de hornear. Extiéndala hasta conseguir una capa fina, deje que se enfríe y corte círculos de 5 cm de diámetro aproximadamente.

Reparta el sorbete de piña y el sorbete de coco en dos capas sobre los copos de praliné y congélelo inmediatamente. Decore con naranja y menta cortadas en juliana, zarzamora y salsa de frambuesa.

180 ml di acqua
100 g di zucchero
4 cucchiai di glucosio
180 g di purea di ananas
180 ml di latte di noce di cocco

Portate ad ebollizione l'acqua, scioglietevi lo zucchero e il glucosio e fate bollire per 2 minuti. Versate il tutto in due ciotole (di plastica o metallo), incorporate la purea di ananas in una ciotola e il latte di noce di cocco nell'altra, e mettete a congelare per almeno 5 ore. Mescolate di tanto in tanto.

100 g di nougat
100 g di cioccolato bianco
150 g di corn-flakes sbriciolati
Per decorare:
Arancia e menta alla julienne, salsa di more e lamponi

Fate sciogliere il nougat e il cioccolato a bagnomaria, incorporatevi i corn-flakes. Distribuite il composto su un foglio di carta da forno formando uno strato sottile e uniforme, e lasciate raffreddare. Ritagliate dei cerchi di ca. 5 cm di diametro.

Distribuite uno strato di sorbetto di ananas e uno di noce di cocco sulle scaglie di nougat e mettete subito a congelare. Servite con arancia e menta alla julienne, salsa di more e lamponi.

Bazaar Restaurant

Design: Filip Šorm | Chef: Marek Raditsch | Owner: Nils Jebens

Nerudova 40 | 118 00 Prague | Prague 1
Phone: +420 296 826 105
www.kampagroup.com | kontakt@restaurantbazaar.com
Subway: Malostranské náměstí
Opening hours: Restaurant every day 6 am to midnight,
Terrace summer season 11 am to 11 pm, winter season noon to 6 pm
Average price: Czk 245
Cuisine: Mediterranean, Steak specialities

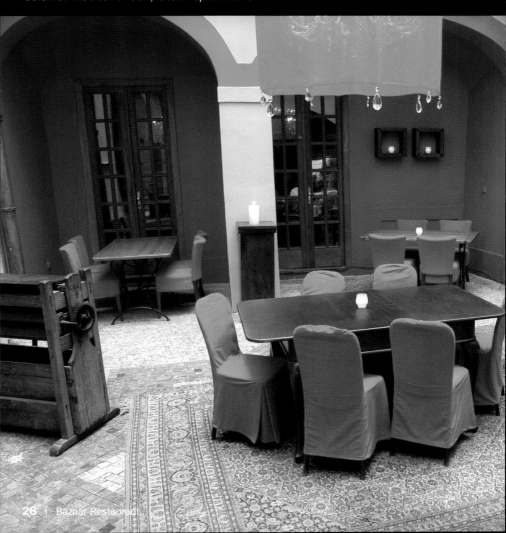

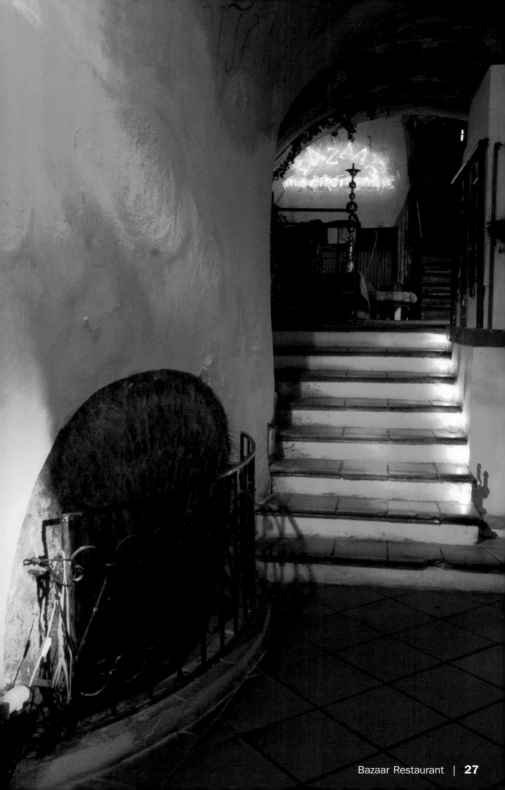

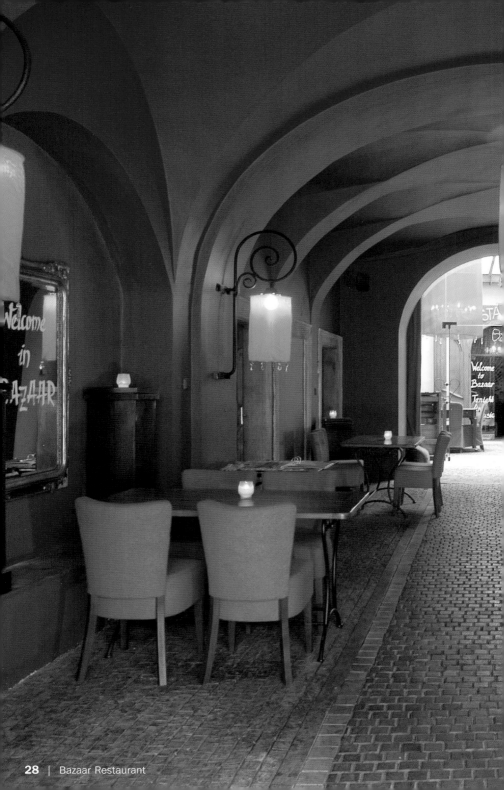

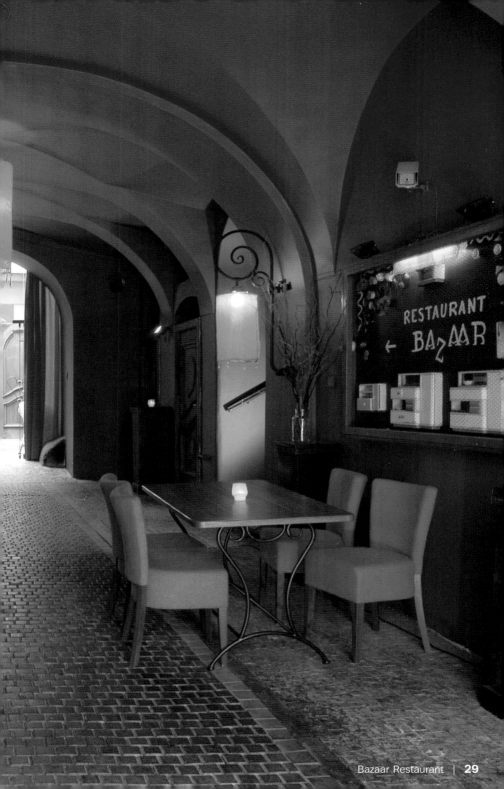

Tomato Risotto
with Italian Sausage and Gorgonzola

Tomatenrisotto mit italienischer Wurst und Gorgonzola

Risotto de tomates aux saucisses italiennes et au gorgonzola

Risotto de tomate con salchicha italiana y queso gorgonzola

Risotto ai pomodori con salsiccia e gorgonzola

2 shallots, diced
6 tomatoes, peeled
6 tbsp olive oil
8 1/2 oz rice
720 ml vegetable stock
210 ml white wine
6 oz Gorgonzola
3 tbsp butter
7 oz fresh spinach, chopped
Salt, pepper

4 Italian sausages
2 oz Gorgonzola, crumbled
2 tbsp olive oil
2 tbsp fresh spinach, chopped

Sauté the shallots and tomatoes with 2 tbsp of olive oil in a small pan over medium heat about 2–3 minutes, until they are soft. Fry the rice in 4 tbsp of olive oil for 3 minutes in a medium-sized pot over medium heat, stirring constantly. Add the tomato-shallot mixture, vegetable stock and wine and cook for about 15 minutes. Stirring constantly, slowly add the Gorgonzola and chilled butter. Then add the spinach and season to taste.

Cook the sausages in a large frying pan over medium heat until done. Spoon the risotto onto deep plates and add crumbled Gorgonzola and a grilled sausage. Drizzle with olive oil and garnish with spinach.

2 Schalotten, gewürfelt
6 Tomaten, gehäutet
6 EL Olivenöl
240 g Reis
720 ml Gemüsebrühe
210 ml Weißwein
180 g Gorgonzola
3 EL Butter
210 g frischer Spinat, gehackt
Salz, Pfeffer

4 italienische Würste
60 g Gorgonzola, zerbröselt
2 EL Olivenöl
2 EL frischer Spinat, gehackt

In einem kleinen Topf bei mittlerer Hitze die Schalotten und Tomaten in 2 EL Olivenöl weich garen, ca. 2–3 Minuten. In einem mittleren Topf bei mittlerer Hitze den Reis für 3 Minuten in 4 EL Olivenöl anschwitzen, dabei ständig rühren. Die Tomaten-Schalottenmischung, Gemüsebrühe und Wein dazugeben und für ca. 15 Minuten kochen. Unter ständigem Rühren langsam den Gorgonzola und die kalte Butter zugeben. Dann den Spinat unterrühren und abschmecken.

Die Würste in einer großen Pfanne bei mittlerer Hitze durchgaren. Das Risotto in tiefe Teller geben und zerbröselten Gorgonzola und eine gegrillte Wurst daraufgeben. Mit Olivenöl beträufeln und mit dem Spinat garnieren.

2 échalotes, coupées en dés
6 tomates, pelées
6 c. à soupe d'huile d'olive
240 g de riz
720 ml de bouillon de légumes
210 ml de vin blanc
180 g de gorgonzola
3 c. à soupe de beurre
210 g d'épinards frais, hachés
Sel, poivre

4 saucisses italiennes
60 g de gorgonzola, émietté
2 c. à soupe d'huile d'olive
2 c. à soupe d'épinards frais, hachés

Dans une petite casserole, cuire à feu moyen les échalotes et les tomates dans 2 c. à soupe d'huile d'olive jusqu'à ce qu'elles soient tendres, pendant 2–3 minutes environ. Dans une casserole moyenne, faire suer le riz à feu moyen pendant 3 minutes dans 4 c. à soupe d'huile d'olive, remuer constamment. Ajouter le mélange de tomates et d'échalotes, le bouillon de légumes et le vin et faire cuire pendant 15 minutes environ. Tout en remuant, ajouter lentement le gorgonzola et le beurre froid. Incorporer ensuite les épinards et assaisonner.

Dans une grande poêle, faire cuire les saucisses à feu moyen. Placer le risotto dans des assiettes creuses et ajouter par dessus le gorgonzola émietté et une saucisse grillée. Arroser d'huile d'olive et garnir avec les épinards.

2 chalotes, en dados
6 tomates, pelados
6 cucharadas de aceite de oliva
240 g de arroz
720 ml de caldo de verdura
210 ml de vino blanco
180 g de queso gorgonzola
3 cucharadas de mantequilla
210 g de espinacas frescas, picadas
Sal, pimienta

4 salchichas italianas
60 g de queso gorgonzola, desmenuzado
2 cucharadas de aceite de oliva
2 cucharadas de espinacas frescas, picadas

Rehogue en una cazuela pequeña a fuego medio y durante 2-3 minutos los chalotes y los tomates en 2 cucharadas de aceite de oliva. En una cazuela mediana, sofría el arroz a fuego medio durante 3 minutos con 4 cucharadas de aceite de oliva y sin dejar de remover. Incorpore la mezcla de los tomates y los chalotes, el caldo de verdura y el vino y cueza durante 15 minutos aproximadamente. Añada lentamente el queso gorgonzola y la mantequilla fría sin dejar de remover. Introduzca finalmente las espinacas, remueva y salpimiente al gusto.

Fría las salchichas en una sartén grande a fuego medio. Ponga el *risotto* en platos hondos. Esparza con el queso gorgonzola desmenuzado y coloque encima una salchicha asada. Vierta por encima el aceite de oliva y adorne con la espinaca.

2 scalogni tagliati a dadini
6 pomodori pelati
6 cucchiai di olio d'oliva
240 g di riso
720 ml di brodo vegetale
210 ml di vino bianco
180 g di gorgonzola
3 cucchiai di burro
210 g di spinaci freschi tritati
Sale, pepe

4 salsicce
60 g di gorgonzola sbriciolato
2 cucchiai di olio d'oliva
2 cucchiai di spinaci freschi tritati

In una pentola piccola fate appassire gli scalogni e i pomodori in 2 cucchiai di olio d'oliva a fuoco medio per ca. 2–3 minuti. In una pentola media fate dorare il riso in 4 cucchiai di olio d'oliva a fuoco medio per 3 minuti mescolando di continuo. Aggiungete i pomodori e gli scalogni, il brodo vegetale e il vino e fate cuocere per ca. 15 minuti. Sempre mescolando, aggiungete il gorgonzola e il burro freddo. Incorporatevi quindi gli spinaci e correggete di sapore.

In una padella grande fate cuocere bene le salsicce a fuoco medio. Mettete il risotto in un piatto fondo e disponetevi sopra il gorgonzola sbriciolato e una salsiccia ai ferri. Versatevi alcune gocce di olio d'oliva e guarnite con gli spinaci.

Bellavista Prague

Design: Ota Blaha | Chef: Michal Stepanek
Owner: Kolkovna Group a.s.

Strahovské nádvoří 1 | 110 00 Prague | Prague 1
Phone: +420 220 517 274
www.bella-vista.cz | info@bella-vista.cz
Subway: Malostranské náměstí
Opening hours: Every day 10 am to midnight
Average price: Czk 950
Cuisine: Italian, International
Special features: The most beautiful view to Prague from summer terrace

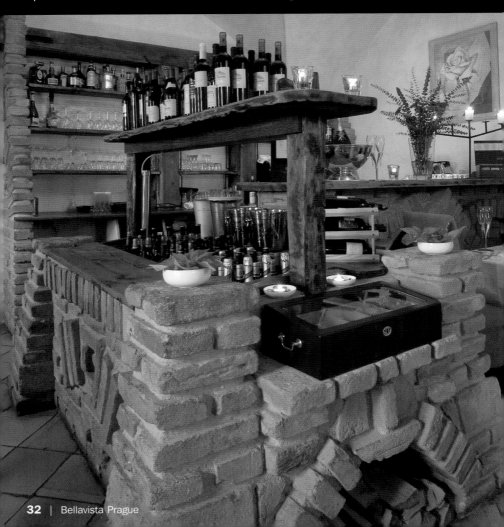

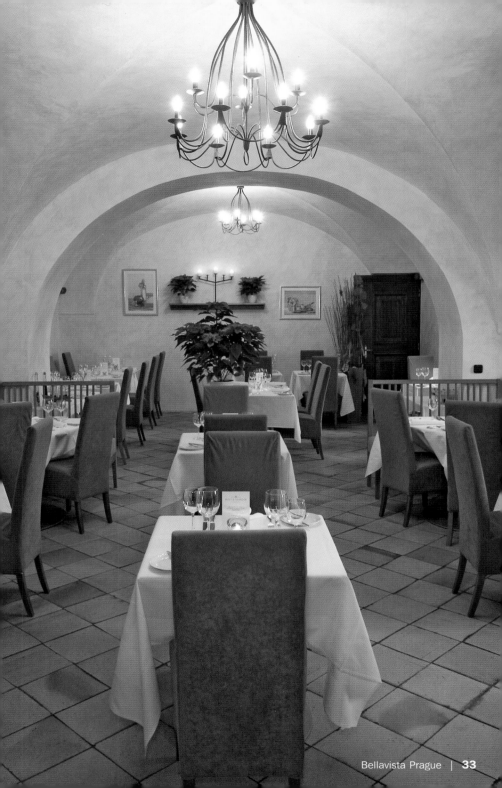

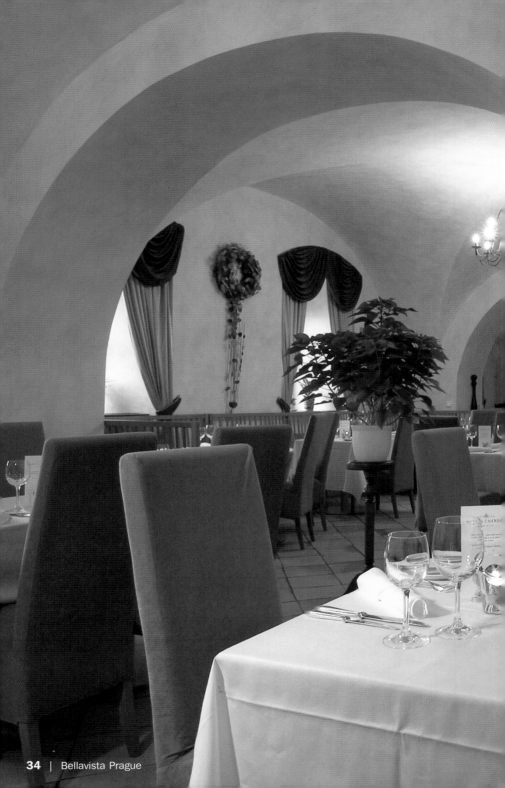

Tiger Prawns
with Tomato Tartar and Lemon Aioli

Tigergarnelen mit Tomatentartar
und Zitronenaioli

Crevettes tigrées au tartare de tomates
et à l'aïoli au citron

Langostinos tigre con tartar de tomate
y mayonesa con ajo y limón

Mazzancolle con tartara di pomodori
e aioli al limone

16 tiger prawns, cleaned
1 clove of garlic, sliced
1 tsp chili powder
3 tbsp olive oil

3 large tomatoes, peeled, seeded, diced
6 basil leaves, chopped
2 tbsp olive oil
Sugar

1 egg yolk
Juice of 1 lemon
100–120 ml olive oil
Salt, pepper

Mix egg yolk with lemon juice and whip until creamy. Slowly add the olive oil until it resembles a smooth mixture similar to mayonnaise. Season with salt and pepper. Mix diced tomatoes with basil and olive oil and season to taste. Sauté tiger prawns and seasoning in hot olive oil for approx. 3 minutes. Place 4 tiger prawns on each plate, spoon tomato tartar beside them and drizzle with lemon aioli.

16 Tigergarnelen, geputzt
1 Knoblauchzehe, in Scheiben geschnitten
1 TL Chilipulver
3 EL Olivenöl

3 große Tomaten, gehäutet, entkernt, gewürfelt
6 Basilikumblätter, gehackt
2 EL Olivenöl
Zucker

1 Eigelb
Saft einer Zitrone
100–120 ml Olivenöl
Salz, Pfeffer

Das Eigelb mit dem Zitronensaft vermischen und so lange schlagen, bis es cremig wird. Langsam das Olivenöl zugeben, bis es eine glatte Mischung ergibt, ähnlich wie Mayonnaise. Mit Salz und Pfeffer würzen. Die gewürfelten Tomaten mit Basilikum und Olivenöl mischen und mit Salz, Pfeffer und Zucker abschmecken. Die Tigergarnelen und die Gewürze in heißem Olivenöl für ca. 3 Minuten sautieren. Auf jeden Teller 4 Tigergarnelen geben, das Tomatentartar daneben anrichten und mit Zitronenaioli beträufeln.

16 crevettes tigrées, nettoyées
1 gousse d'ail, coupée en tranches
1 c. à café de piment rouge en poudre
3 c. à soupe d'huile d'olive

3 grosses tomates, pelées, épépinées, coupées en dés
6 feuilles de basilic, hachées
2 c. à soupe d'huile d'olive
Sucre

1 jaune d'œuf
Le jus d'un citron
100–120 ml d'huile d'olive
Sel, poivre

Mélanger le jaune d'œuf au jus de citron et le fouetter jusqu'à ce que cela devienne crémeux. Ajouter lentement l'huile d'olive pour obtenir un mélange lisse, semblable à une mayonnaise. Saler et poivrer. Mélanger les tomates coupées en dés avec le basilic et l'huile d'olive et épicer avec du sel, du poivre et du sucre. Faire sauter les crevettes tigrées et les épices dans de l'huile d'olive chaude pendant environ 3 minutes. Placer 4 crevettes tigrées par assiette, disposer le tartare de tomates à coté et arroser d'aïoli au citron.

16 langostinos tigre, limpios
1 diente de ajo, en láminas
1 cucharadita de guindilla molida
3 cucharadas de aceite de oliva

3 tomates grandes, pelados, despepitados, en dados
6 hojas de albahaca, picadas
2 cucharadas de aceite de oliva
Azúcar

1 yema
Zumo de un limón
100-120 ml de aceite de oliva
Sal, pimienta

Mezcle la yema con el zumo de limón y bata hasta conseguir una consistencia cremosa. Añada lentamente el aceite de oliva hasta obtener una mezcla homogénea parecida a la mayonesa. Salpimiente al gusto. Incorpore el tomate y la albahaca junto con el aceite, la sal, la pimienta y el azúcar y remueva. Introduzca los langostinos con las especias en una sartén con aceite caliente y fría durante 3 minutos aproximadamente. Ponga 4 langostinos en cada plato, disponga el tartar de tomate al lado y vierta por encima la mayonesa de ajo y limón.

16 mazzancolle pulite
1 spicchio d'aglio tagliato a fettine
1 cucchiaino di polvere di chili
3 cucchiai di olio d'oliva

3 pomodori grossi, pelati, privati dei semi e tagliati a dadini
6 foglie di basilico tritate
2 cucchiai di olio d'oliva
Zucchero

1 tuorlo d'uovo
Succo di un limone
100–120 ml di olio d'oliva
Sale, pepe

Sbattete il tuorlo d'uovo con il succo di limone finché avrà assunto una consistenza cremosa. Aggiungete lentamente l'olio d'oliva fino ad ottenere un composto liscio, simile alla maionese. Salate e pepate. Mescolate i pomodori tagliati a dadini con il basilico e l'olio d'oliva e correggete di sale, pepe e zucchero. Fate saltare le mazzancolle e le spezie in olio d'oliva bollente per ca. 3 minuti. Mettete su ogni piatto 4 mazzancolle, disponete vicino la tartara di pomodori e versatevi alcune gocce di aioli al limone.

Café BOGNER

Design: Barbora Vančurová | Chef: Robert Kolomý

Michalská 19 / Jilská 18 | 110 00 Prague | Prague 1
Phone: +420 225 777 150
www.cafebogner.cz | info@cafebogner.cz
Subway: Můstek
Opening hours: Every day 7:30 am to 11 pm
Average price: Czk 180
Cuisine: Fresh, Modern

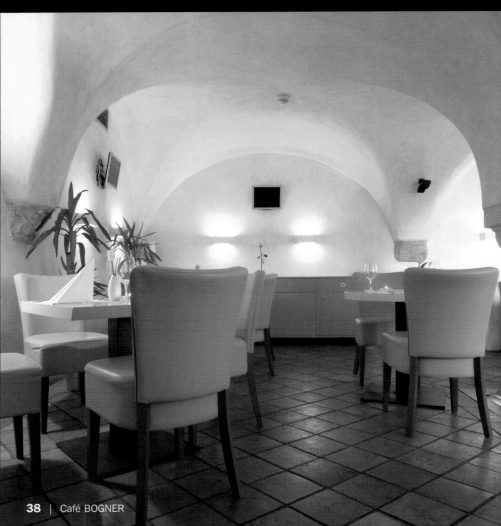

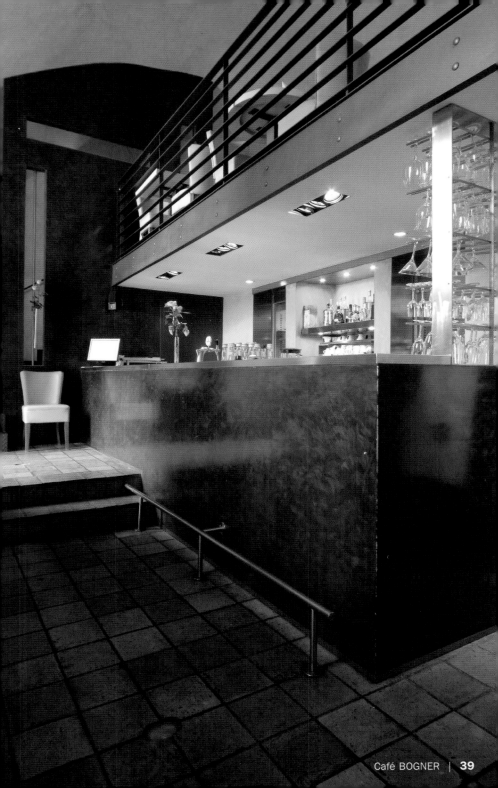

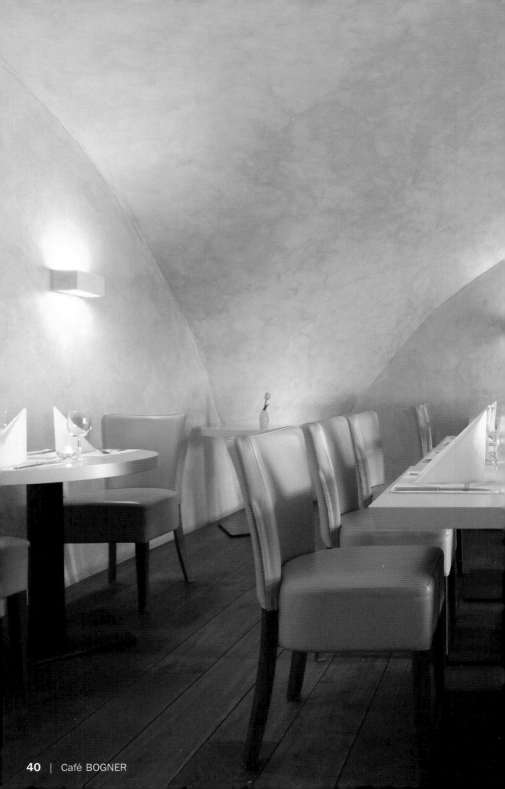

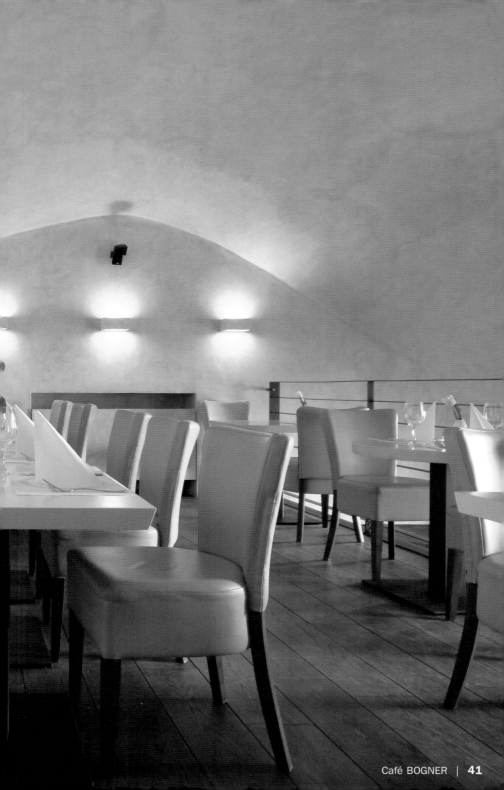

Café La Veranda

Design: Tomáš Turek | Chef: Radek David | Owner: Yuri Kolesnik

Elišky Krásnohorské 2/10 | 110 00 Prague | Prague 1
Phone: +420 224 814 733
www.laveranda.cz | office@laveranda.cz
Subway: Staroměstská
Opening hours: Every day 11 am to midnight
Average price: Czk 1200
Cuisine: Creative International, Fusion
Special features: Charming atmosphere in modern design; organic food with Asian influence; rich wine cellar

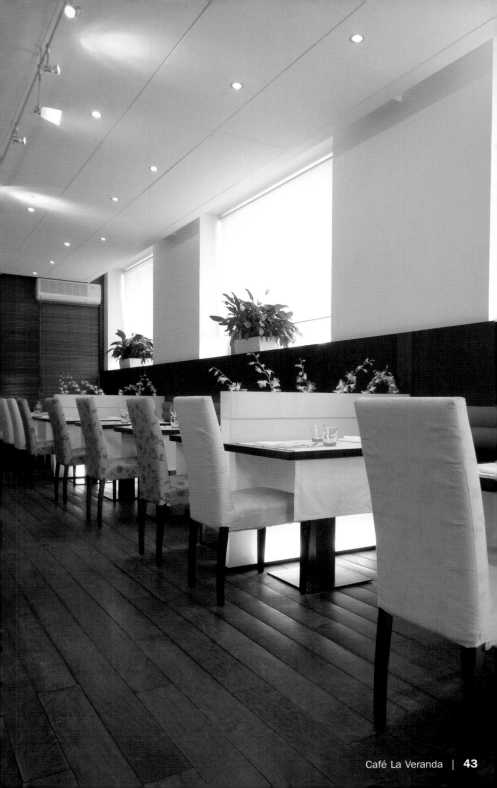

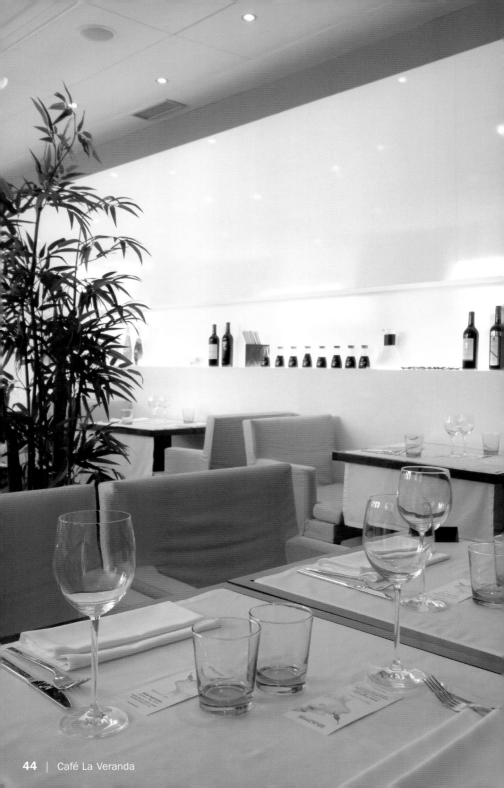

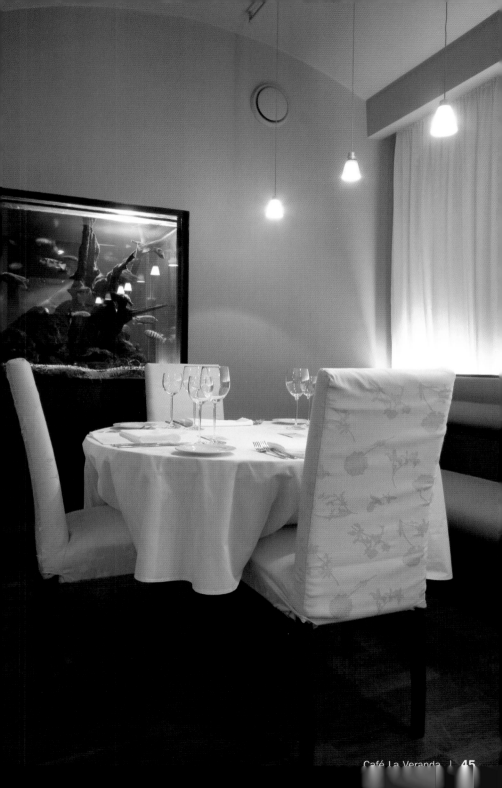

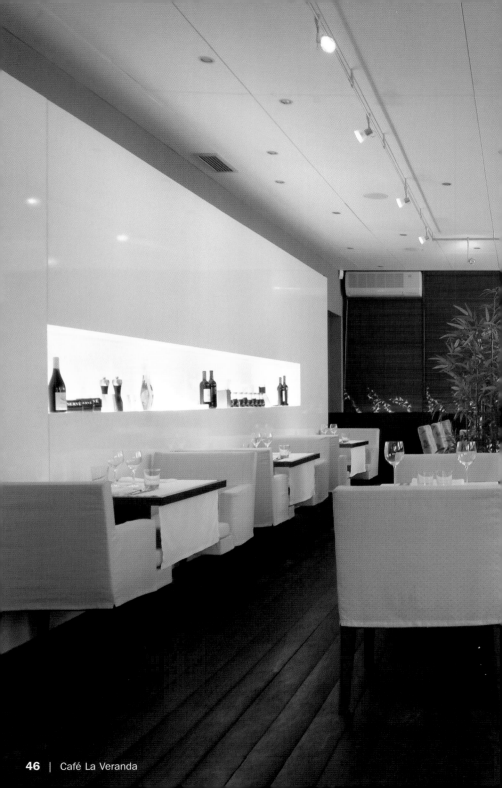

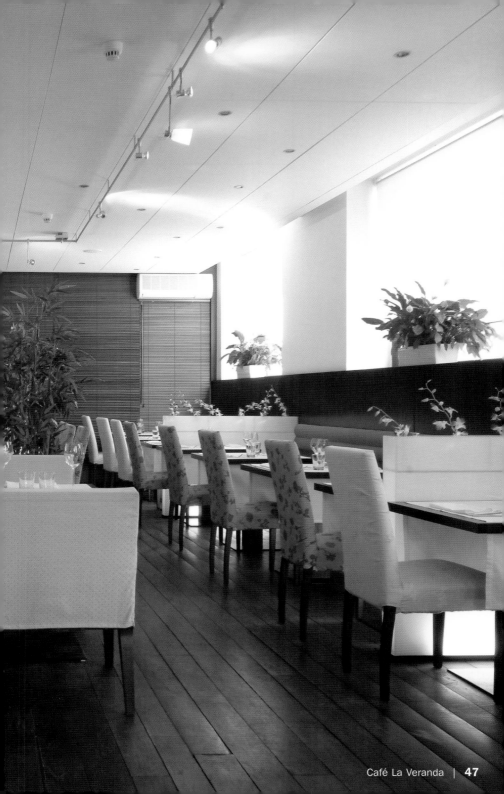

Divinis

Design: Luciano Belcapo | Chef: Martin Polačko
Owner: Pino Confessa

Týnská 23 | 110 00 Prague | Prague 1
Phone: +420 222 325 440
www.divinis.cz | info@divinis.cz
Subway: Staroměstská
Opening hours: Every day 3 pm to 2 am
Average price: Czk 900
Cuisine: Italian

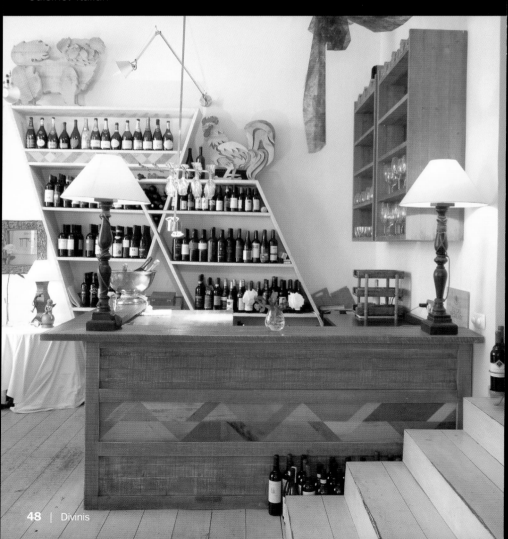

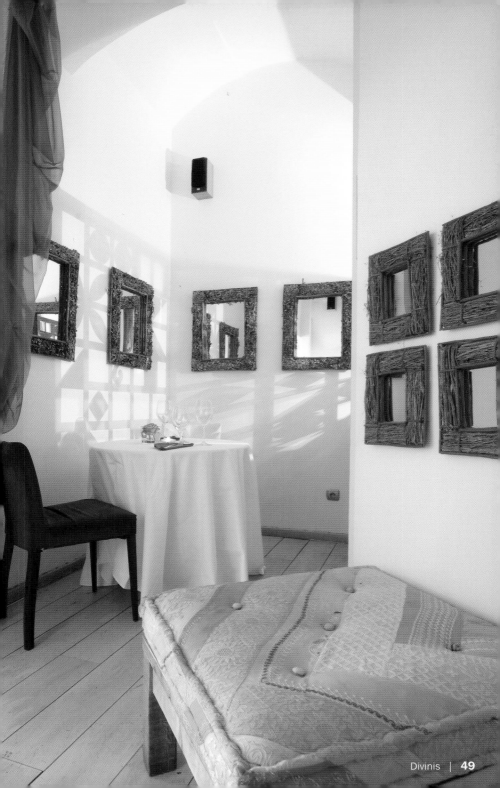

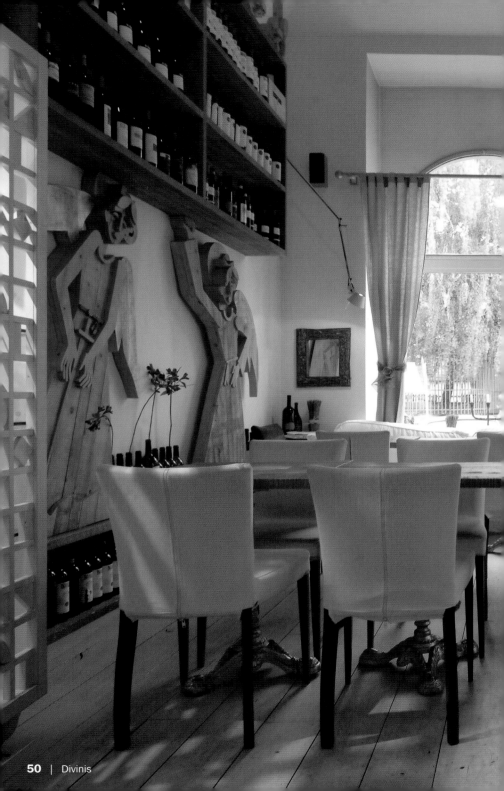

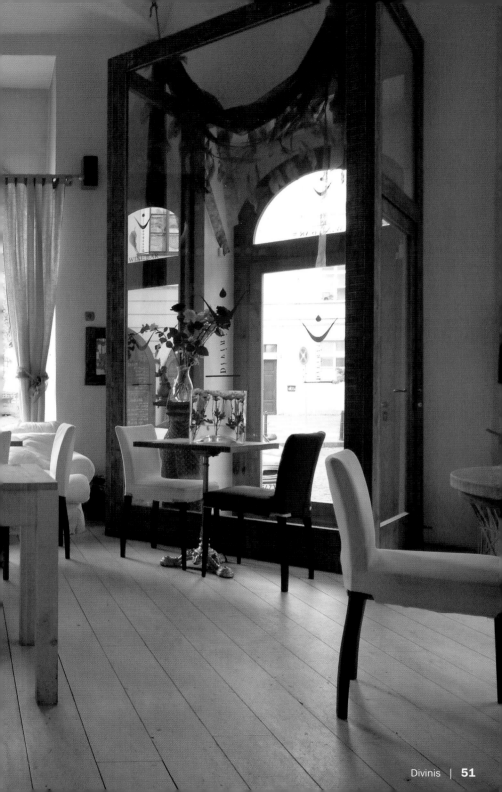

Marinated Tuna
with Fennel Seeds

Marinierter Tunfisch mit Fenchelsamen
Thon mariné aux graines de fenouil
Atún marinado con semillas de hinojo
Tonno marinato con semi di finocchio

4 pieces of tuna, 6 oz each
Salt, pepper
4 tbsp fennel seeds, coarsely ground
3 tbsp olive oil

For decoration:
Balsamic vinegar
Lettuce
Carrot and zucchini julienne

Season tuna with salt and pepper and toss in fennel seeds. Heat oil in a pan and fry tuna for 3 minutes on each side. Place in a 320 °F oven for approx. 5 minutes. Cut tuna fillets in half and serve with lettuce, carrots and zucchini and a drizzle of balsamic vinegar.

4 Stück Tunfisch, je 180 g
Salz, Pfeffer
4 EL Fenchelsamen, grob gemahlen
3 EL Olivenöl

Zur Dekoration:
Balsamessig
Salat
Möhren- und Zucchinijulienne

Den Tunfisch mit Salz und Pfeffer würzen und in den Fenchelsamen wälzen. Das Öl in einer Pfanne erhitzen und den Tunfisch auf jeder Seite 3 Minuten anbraten. Für ca. 5 Minuten in einen 160 °C heißen Ofen geben. Tunfischfilets halbieren und mit Salat, Möhren und Zucchini und etwas Balsamessig servieren.

4 morceaux de thon de 180 g chacun
Sel, poivre
4 c. à soupe de graines de fenouil, grossièrement
moulues
3 c. à soupe d'huile d'olive

Pour la décoration :
Vinaigre balsamique
Salade
Julienne de carottes et de courgettes

Saler et poivrer le thon et le rouler dans les graines de fenouil. Faire chauffer de l'huile dans une poêle et griller le thon pendant 3 minutes sur chaque coté. Mettre pendant 5 minutes au four préchauffé à 160 °C. Couper les filets de thon en deux et servir avec de la salade, des carottes et des courgettes et un peu de vinaigre balsamique.

4 filetes de atún, de 180 g cada uno
Sal, pimienta
4 cucharadas de semillas de hinojo, ligeramente
molidas
3 cucharadas de aceite de oliva

Para decorar:
Vinagre balsámico
Lechuga
Zanahoria y calabacín cortados en juliana

Salpimiente el atún y esparza por encima las semillas de hinojo. Caliente el aceite en una sartén y fría los filetes 3 minutos por cada lado. Introdúzcalos después en un horno precalentado a 160 °C y áselos durante 5 minutos aproximadamente. Corte los filetes por la mitad. Póngalos en los platos, decore con la lechuga, la zanahoria, el calabacín y el vinagre balsámico y sirva.

4 pezzi di tonno da 180 g l'uno
Sale, pepe
4 cucchiai di semi di finocchio macinati grosso-
lanamente
3 cucchiai di olio d'oliva

Per decorare:
Aceto balsamico
Insalata
Carote e zucchine alla julienne

Salate e pepate il tonno e passatelo nei semi di finocchio. In una padella scaldate l'olio e fatevi rosolare il tonno per 3 minuti per lato. Passate in forno caldo a 160 °C per ca. 5 minuti. Dividete i filetti di tonno a metà e serviteli con insalata, carote e zucchine e un po' di aceto balsamico.

Hergetova Cihelna

Design: Barbora Škorpilova | Chef: Marek Raditsch
Owner: Nils Jebens

Cihelná 2b | 118 00 Prague | Prague 1
Phone: +420 296 826 103
www.kampagroup.com | kontakt@cihelna.com
Subway: Malostranské náměstí
Opening hours: Every day 11:30 am to 1 am
Average price: Czk 325
Cuisine: International, Czech specialities

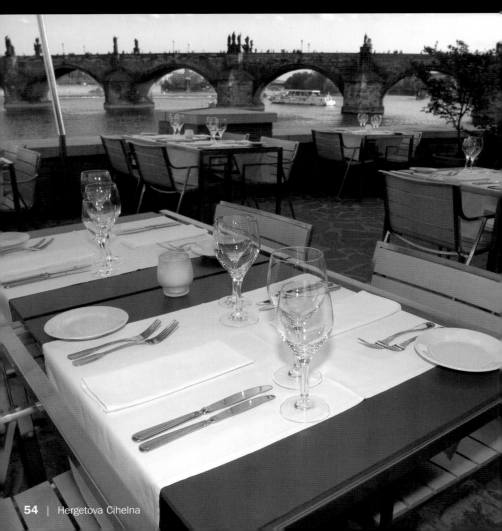

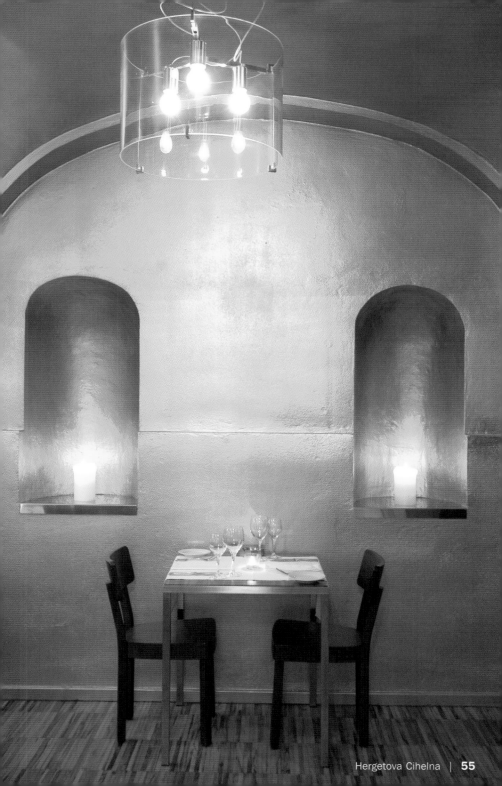

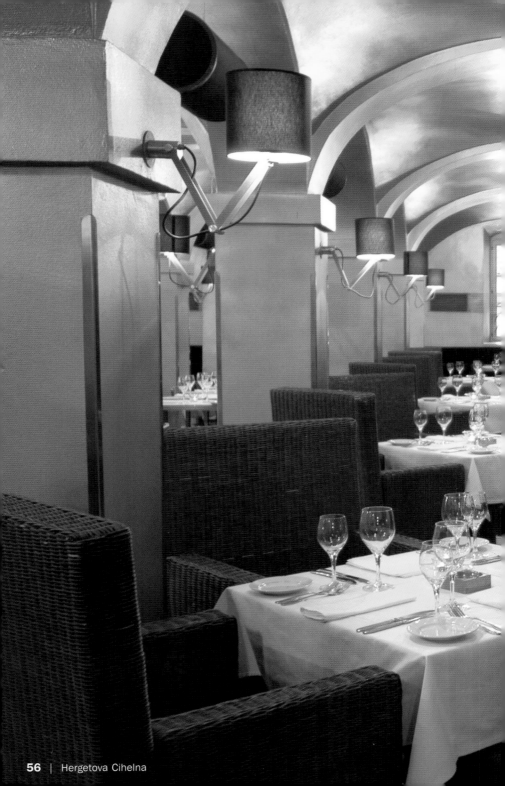

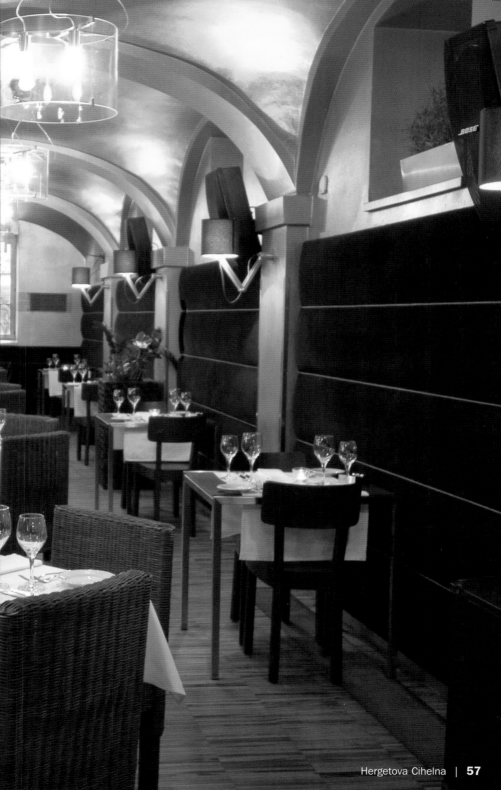

Red & Green Pear Salad
with Montbriac Cheese

Salat von roter und grüner Birne
mit Montbriac-Käse

Salade de poires rouges et vertes
au fromage de Montbriac

Ensalada de pera roja y verde
con queso montbriac

Insalata di pere rosse e verdi
con formaggio Montbriac

2 shallots, diced
100 ml olive oil
2 tbsp sugar
60 ml champagne vinegar
Salt, pepper

4 Belgian endives
2 pears, 1 green and 1 red
8 1/2 oz Montbriac cheese
2 oz walnuts

4 tbsp olive oil
100 ml sherry vinegar

Brown the diced shallots in olive oil over medium heat for 10–15 minutes. Allow to cool, and then mix in a blender. Add sugar, salt and pepper to taste. Stir in the champagne vinegar and set aside.
Clean the endives and cut into strips. Halve each of the pears, removing the seeds and cores and slice into long, thin strips. Cut the cheese into matchbox-sized cubes and roughly chop the walnuts.
Just before serving, toss the salad thoroughly with all other ingredients in a large salad bowl, allowing all flavors to combine. Drizzle with olive oil and sherry vinegar.

2 Schalotten, gewürfelt
100 ml Olivenöl
2 EL Zucker
60 ml Champagneressig
Salz, Pfeffer

4 belgische Endiviensalate
2 Birnen, 1 grüne und 1 rote
240 g Montbriac-Käse
60 g Walnüsse

4 EL Olivenöl
100 ml Sherryessig

Die gewürfelten Schalotten in Olivenöl bei mittlerer Hitze 10–15 Minuten anschmoren. Abkühlen lassen, dann in einer Küchenmaschine mixen. Mit Zucker, Salz und Pfeffer abschmecken. Mit dem Champagneressig mischen und beiseite stellen.
Endiviensalat putzen und in Streifen schneiden. Jede Birne halbieren, das Kerngehäuse entfernen und in lange, dünne Streifen schneiden. Den Käse in Würfel von der Größe einer Streichholzschachtel schneiden und die Walnüsse in grobe Stücke hacken.
In einer großen Salatschüssel den Salat und alle anderen Zutaten gründlich unterheben, um die Aromen zu vermischen. Mit Olivenöl und Sherryessig beträufeln.

2 échalotes, coupées en dés
100 ml d'huile d'olive
2 c. à soupe de sucre
60 ml de vinaigre de Champagne
Sel, poivre

4 chicons belges
2 poires, 1 verte et 1 rouge
240 g de fromage de Montbriac
60 g de noix

4 c. à soupe d'huile d'olive
100 ml de vinaigre de Sherry

Faire étuver dans de l'huile d'olive à feu moyen les échalotes coupées en dés pendant 10–15 minutes. Laisser refroidir, puis passer au mixer. Assaisonner de sucre, de sel et de poivre. Mélanger au vinaigre de Champagne et laisser reposer.
Nettoyer les chicons et les couper en lamelles. Diviser chaque poire en deux, enlever le trognon et couper en longues et fines lamelles. Couper le fromage en dés de la taille d'une boîte d'allumettes et hacher grossièrement les noix.
Bien incorporer dans un grand saladier la salade et tous les autres ingrédients pour mélanger les arômes. Arroser d'huile d'olive et de vinaigre de Sherry.

2 chalotes, en dados
100 ml de aceite de oliva
2 cucharadas de azúcar
60 ml de vinagre de champán
Sal, pimienta

4 endivias belgas
2 peras, 1 verde y 1 roja
240 g de queso montbriac
60 g de nueces

4 cucharadas de aceite de oliva
100 ml de vinagre de jerez

Rehogue los chalotes troceados en el aceite de oliva y a fuego medio entre 10-15 minutos. Deje después que se enfríe y páselo por el robot de cocina. Condimente al gusto con el azúcar, la sal y la pimienta. Añada el vinagre de champán, remueva y reserve.
Limpie las endivias y córtelas en juliana. Corte las peras en mitades, deseche los corazones y córtelas en tiras largas y finas. Corte el queso en trozos del tamaño de una caja de cerillas y pique las nueces ligeramente.
En una ensaladera grande mezcle bien la lechuga con los demás ingredientes para mezclar los aromas. Vierta por encima el aceite de oliva y el vinagre de jerez.

2 scalogni tagliati a dadini
100 ml di olio d'oliva
2 cucchiai di zucchero
60 ml di aceto di champagne
Sale, pepe

4 indivie belghe
2 pere, 1 verde e 1 rossa
240 g di formaggio Montbriac
60 g di noci

4 cucchiai di olio d'oliva
100 ml di aceto di sherry

Fate stufare gli scalogni tagliati a dadini in olio d'oliva a fuoco medio per 10–15 minuti. Lasciate raffreddare, frullate quindi in un robot da cucina. Correggete di zucchero, sale e pepe. Mescolate con l'aceto di champagne e mettete da parte.
Pulite l'insalata belga e tagliatela a strisce. Dividete ogni pera a metà, togliete il torsolo e tagliatele a strisce lunghe e sottili. Tagliate il formaggio a tocchetti grossi come una scatola di fiammiferi e tritate le noci grossolanamente.
Mettete l'insalata in un'insalatiera capiente, aggiungetevi tutti gli altri ingredienti e mescolate bene per legare i vari sapori. Versatevi alcune gocce di olio d'oliva e di aceto di sherry.

Holport Café

Design: D3A / Fiala - Prouza - Zima | Chef: Pavel Prochazka

Komunardů 32 | 170 00 Prague | Prague 7
Phone: +420 266 712 821
www.holport.cz | info@holport.cz | www.d3a.cz
Subway: Vltavská, Nádrazí Holesovice
Opening hours: Mon–Fri 8 am to 7 pm, Sat and Sun closed
Average price: Czk 50
Cuisine: International
Special features: Breakfast, longdrinks, spirits

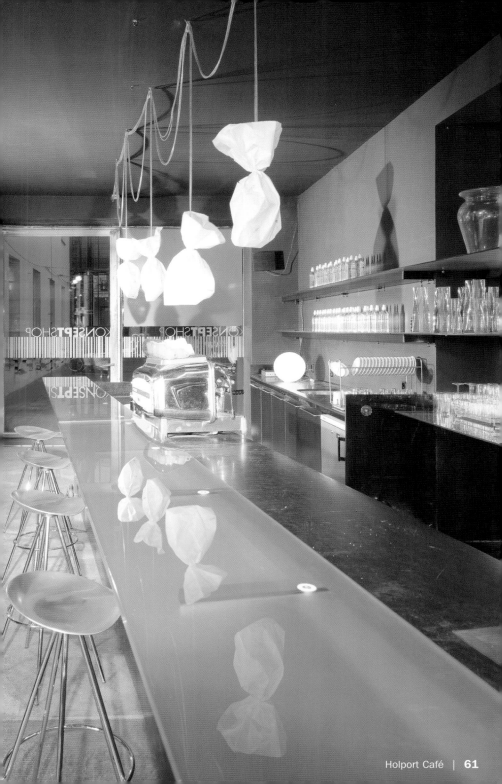

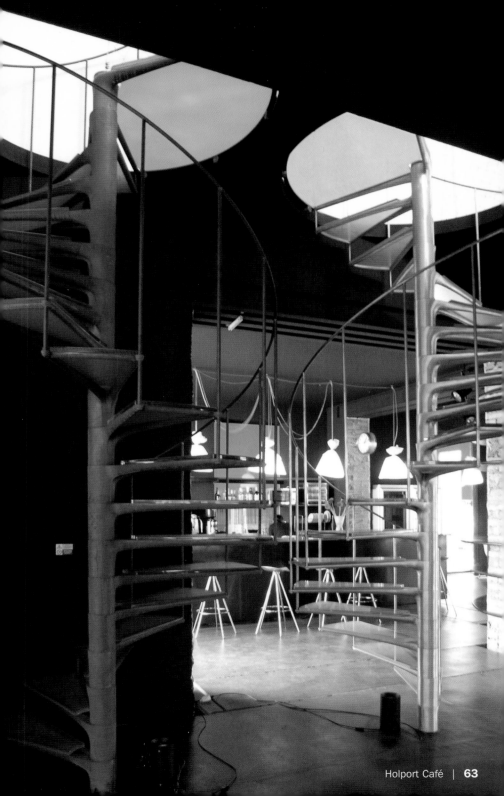

HOT Restaurant

Design | Chef: Miroslav Kotaška, Vong Lianphoukham
Owner: Tommy Sjöö

Václavské náměstí 45 | 110 00 Prague | Prague 1
Phone: +420 222 247 240
www.hot.bacchusgroup.cz | office@bacchusgroup.cz
Subway: Muzeum
Opening hours: Every day 7:30 am to 1 am
Average price: Czk 1000
Cuisine: Thai, Asian, International

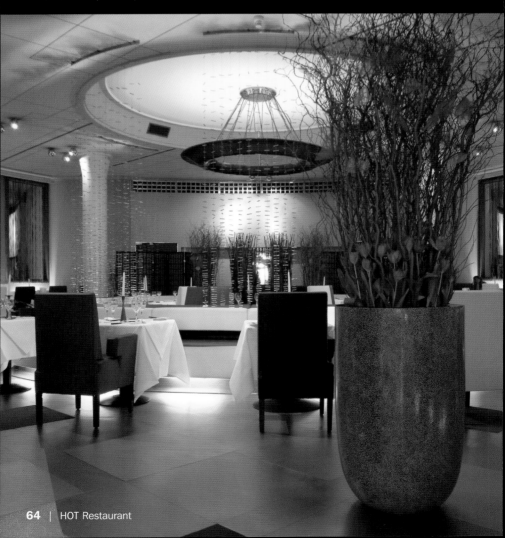

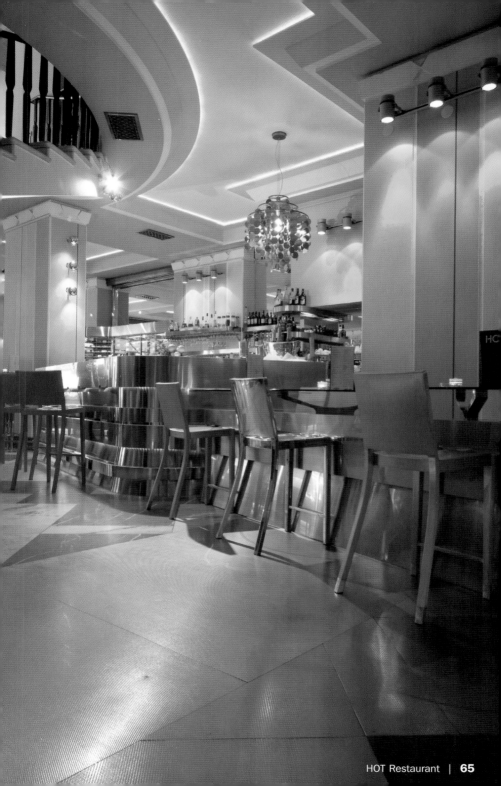

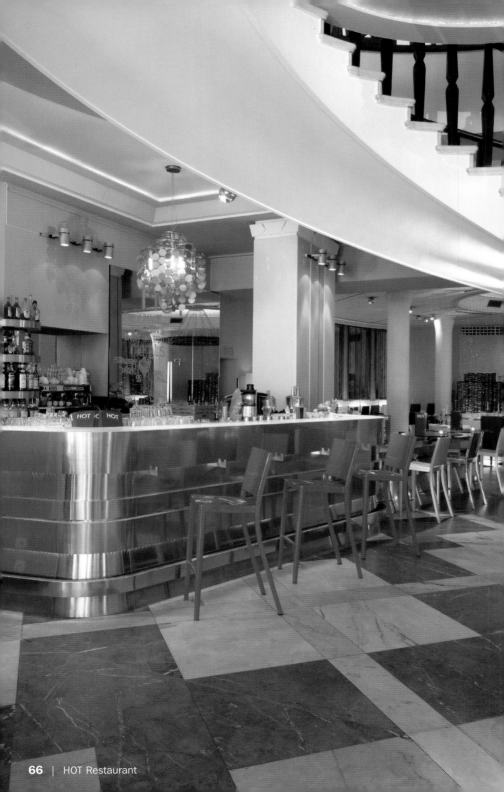

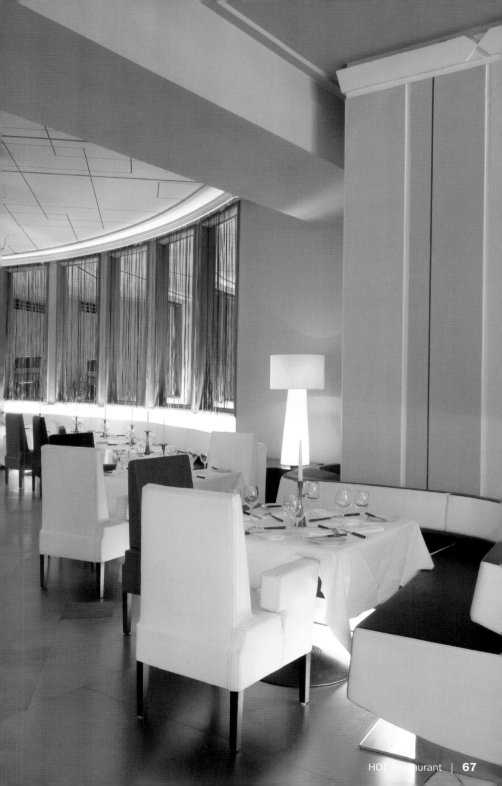

Chicken Breasts

in Pandanus Leaves
with Japanese Salad

Hühnerbrüste in Pandanblättern
mit japanischem Salat

Blancs de poulet entourés de feuilles
de pandanus avec salade japonaise

Pechugas de pollo en hojas de pandan
con lechuga japonesa

Petti di pollo in foglie di pandano
con insalata giapponese

8 chicken breasts
16 pandanus leaves

2 tbsp oyster sauce
2 tbsp soy sauce
2 tbsp fish sauce
1 tsp garlic, chopped
2 tbsp milk
1 tsp coriander seeds, crushed

Cut chicken breasts in half; mix all the ingredients, except the pandanus leaves, in a bowl and marinate in the refrigerator for 12 hours.

2 carrots, grated or julienne
2 white radishes, grated or julienne
2 tbsp fresh coriander leaves, chopped
2 tbsp lemon grass, chopped
2 tbsp of limejuice
Brown sugar, salt
Hoi-Sin sauce

Mix all the ingredients in a bowl, season and chill for at least 2 hours. Remove chicken breasts from the marinade, wrap in pandanus leaves, place in a hot wok and steam for approx. 7–10 minutes. Serve with the Japanese salad and Hoi-Sin sauce.

8 Hühnerbrüste
16 Pandanblätter

2 EL Austersauce
2 EL Sojasauce
2 EL Fischsauce
1 TL Knoblauch, gehackt
2 EL Milch
1 TL Koriandersamen, zerdrückt

Hühnerbrüste halbieren, alle Zutaten außer den Pandanblättern in einer Schüssel vermischen und im Kühlschrank für 12 Stunden marinieren lassen.

2 Möhren, geraspelt oder in Julienne
2 weiße Rettiche, geraspelt oder in Julienne
2 EL frische Korianderblätter, gehackt
2 EL Zitronengras, gehackt
2 EL Limettensaft
Brauner Zucker, Salz
Hoi-Sin-Sauce

In einer Schüssel mischen, würzen und für mindestens 2 Stunden kaltstellen. Die Hühnerbrüste aus der Marinade nehmen, in die Pandanblätter einwickeln und in einem Wok für ca. 7–10 Minuten dünsten. Mit dem japanischen Salat und Hoi-Sin-Sauce servieren.

8 blancs de poulet
16 feuilles de pandanus

2 c. à soupe de sauce à huître
2 c. à soupe de sauce de soja
2 c. à soupe de sauce à poisson
1 c. à café d'ail, haché
2 c. à soupe de lait
1 c. à café de graines de coriandre, écrasées

Diviser en deux les blancs de poulet, mélanger tous les ingrédients, sauf les feuilles de pandanus, dans un saladier et laisser mariner au réfrigérateur pendant 12 heures.

2 carottes, râpées ou en julienne
2 radis blancs, râpés ou en julienne
2 c. à soupe de feuilles de coriandre frais, hachées
2 c. à soupe de citronnelle, hachée
2 c. à soupe de jus de citron vert
Sucre brun, sel
Sauce Hoi-Sin

Mélanger dans un saladier, épicer et mettre au frais pendant au moins 2 heures. Retirer les blancs de poulet de la marinade, les envelopper dans les feuilles de pandanus et étuver dans un wok pendant environ 7–10 minutes. Servir avec la salade japonaise et la sauce Hoi-Sin.

8 pechugas de pollo
16 hojas de pandan

2 cucharadas de salsa de ostras
2 cucharadas de salsa de soja
2 cucharadas de caldo de pescado
1 cucharadita de ajo, picado
2 cucharadas de leche
1 cucharadita de semillas de cilantro, majadas

Corte las pechugas en mitades, mezcle en un cuenco todos los ingredientes excepto las hojas de pandan, y deje marinar la carne en el frigorífico durante 12 horas.

2 zanahorias, ralladas o cortadas en juliana
2 rábanos blancos, rallados o cortados en juliana
2 cucharadas de hojas frescas de cilantro, picadas
2 cucharadas de limoncillo, picado
2 cucharadas de zumo de lima
Azúcar moreno, sal
Salsa hoisin

Mezcle los ingredientes en un cuenco, condiméntelos y deje descansar la mezcla en el frigorífico durante 2 horas como mínimo. Saque las pechugas de la marinada, envuélvelas en las hojas de pandan y cuézalas al vapor en un wok entre 7-10 minutos. Sirva con lechuga japonesa y salsa hoisin.

8 petti di pollo
16 foglie di pandano

2 cucchiai di salsa alle ostriche
2 cucchiai di salsa di soia
2 cucchiai di salsa di pesce
1 cucchiaino di aglio tritato
2 cucchiai di latte
1 cucchiaino di semi di coriandolo schiacciati

Dividete i petti di pollo a metà, mescolate in una ciotola tutti gli ingredienti tranne le foglie di pandano e fate marinare in frigorifero per 12 ore.

2 carote grattugiate o alla julienne
2 rafani bianchi grattugiati o alla julienne
2 cucchiai di foglie di coriandolo tritate
2 cucchiai di cimbopogone tritato
2 cucchiai di succo di limetta
Zucchero di canna, sale
Salsa hoisin

Mescolate gli ingredienti in una ciotola, conditeli e metteteli a raffreddare per almeno 2 ore. Togliete i petti di pollo dalla marinata, avvolgeteli nelle foglie di pandano e fateli cuocere a vapore in un wok per ca. 7–10 minuti. Servite con l'insalata giapponese e la salsa hoisin.

Hotel Josef Bar

Design: Eva Jiricna

Rybná 20 | 110 00 Prague | Prague 1
Phone: +420 221 700 111
www.hoteljosef.com | office@hoteljosef.com | www.ejal.com
Subway: Náměstí Republiky
Opening hours: Every day 9 am to 1 am
Special features: Meeting point to catch Prague's new spirit

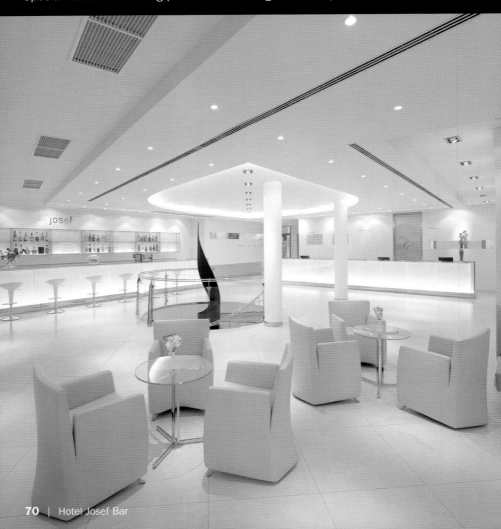

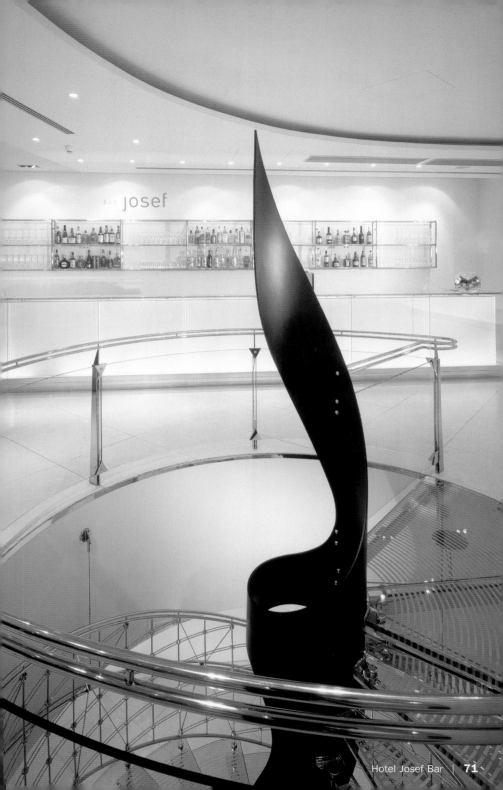

Kampa Park

Design: Barbora Škorpilova | Chef: Marek Raditsch
Owner: Nils Jebens

Na Kampě 8b | 118 00 Prague | Prague 1
Phone: +420 296 826 102
www.kampagroup.com | kontakt@kampagroup.com
Subway: Malostranské náměstí
Opening hours: Every day 11:30 am to 1 am
Average price: Czk 595
Cuisine: International

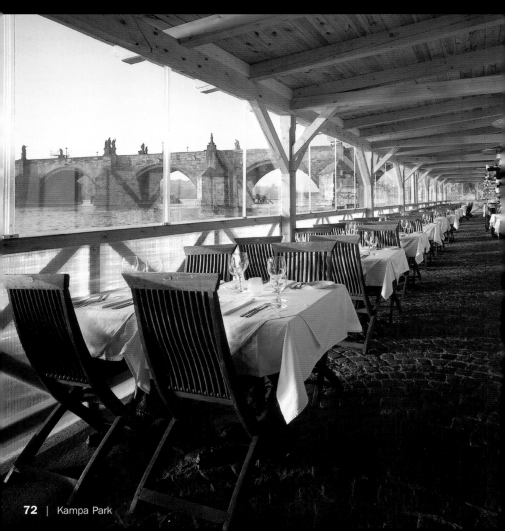

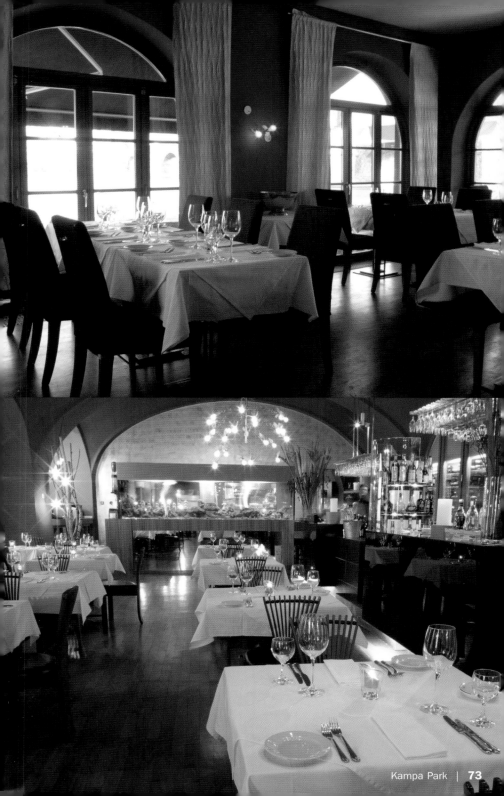

Kolkovna

Design: Jiri Hanzlik | Chef: David Karoch
Owner: Kolkovna Group a.s.

V Kolkovně 8 | 110 00 Prague | Prague 1
Phone: +420 224 819 701
www.kolkovna-group.cz | info@kolkovna.cz
Subway: Staroměstská
Opening hours: Every day 11 am to midnight
Average price: Czk 600
Cuisine: Czech traditional, International
Special features: Unique atmosphere, located in the heart of Prague

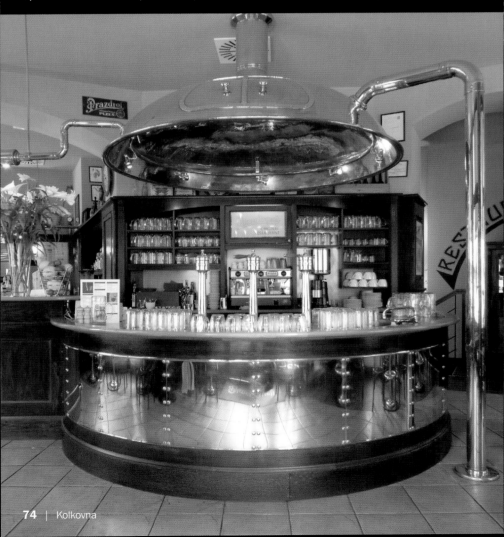

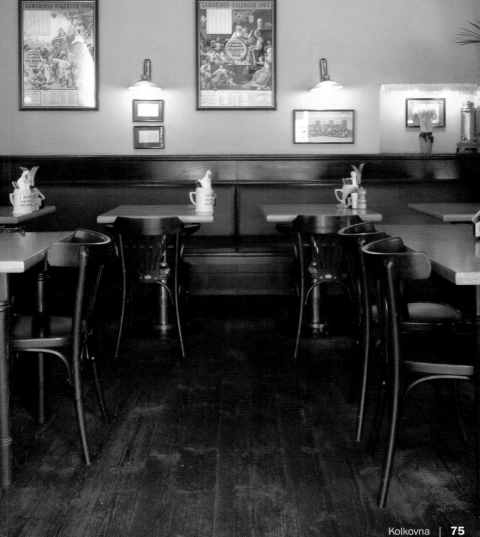

Lacerta

Design: Jakub Turek | Chef: Radek Kuttenberg | Owner: ComPrint

Sokolovská 40 | 180 00 Prague | Prague 8
Phone: +420 222 318 812
www.lacertacz.com | info@lacerta.com.cz
Subway: Florenc
Opening hours: Mon–Fri 10 am to midnight, Sat–Sun noon to midnight
Menue price: Czk 600, lunch and dinner Czk 250
Cuisine: International, French, Czech, Italian, with large selection of Czech and
foreign wines
Special features: Sub-basement restaurant, pleasant atmosphere

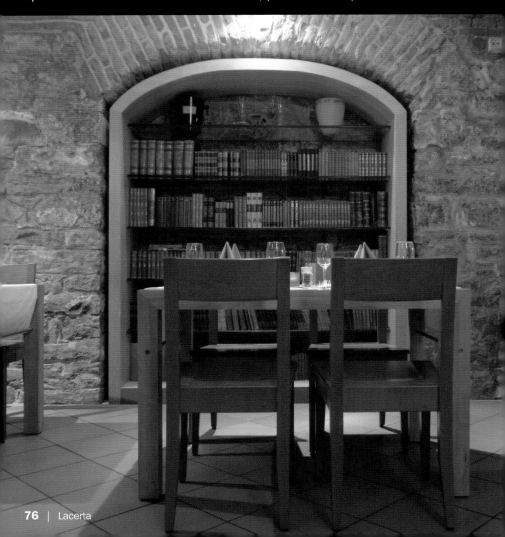

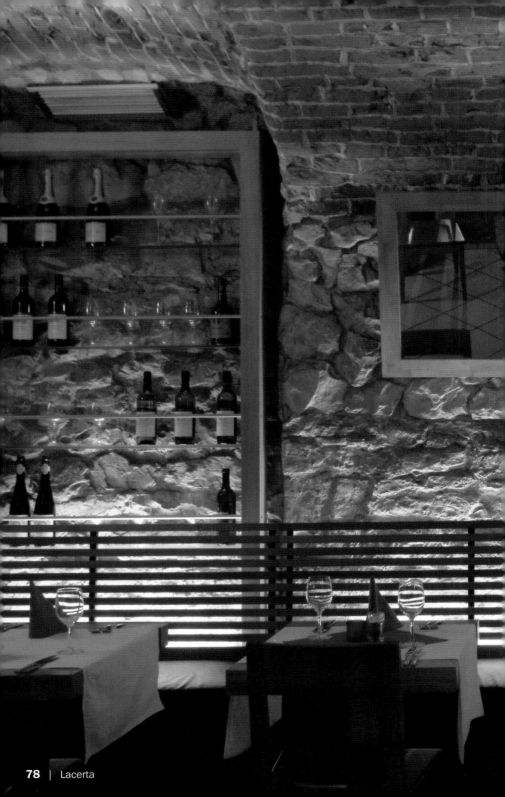

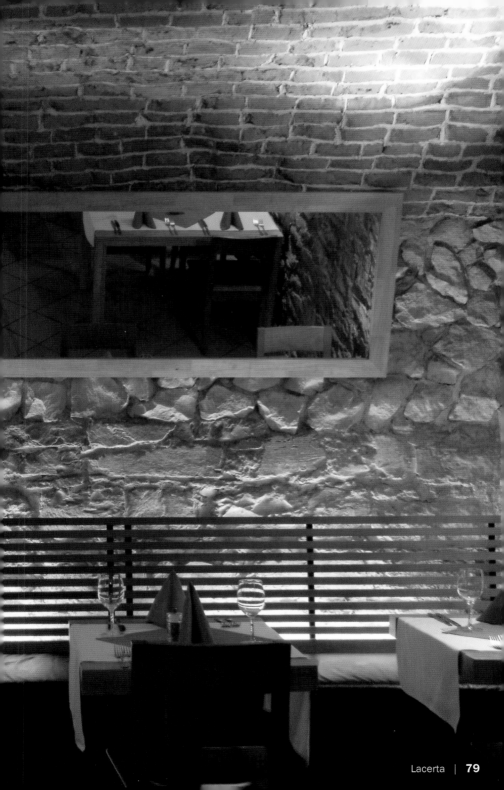

Medallions of Pork with Olives

Schweinemedaillons mit Oliven

Médaillons de porc aux olives

Medallones de cerdo con aceitunas

Medaglioni di maiale con olive

4 pork medallions, 4 oz each, cleaned
4 tbsp stoneless green olives
4 tbsp stoneless black olives

Salt, pepper

240 ml cream
4 tbsp mustard
100 ml red wine
6 tbsp pickled cocktail onions
Salt and pepper
Rice
Lettuce

Cut a pocket in each pork medallion, season and fill with olives. Fasten with a toothpick. Add seasoning to the outside of the meat and sear on each side in a hot pan. Place in a pre-heated oven at 350 °F for approx. 7 minutes. Heat the cream in a small saucepan, add the mustard, red wine and onions and add salt and pepper to taste.

Cut the medallions in half and serve with rice and mustard sauce. Garnish with lettuce.

4 Schweinemedaillons, je 120 g, gesäubert
4 EL grüne Oliven ohne Stein
4 EL schwarze Oliven ohne Stein
Salz, Pfeffer

240 ml Sahne
4 EL Senf
100 ml Rotwein
6 EL eingelegte Cocktailzwiebeln
Salz, Pfeffer
Reis
Blattsalat

Eine Tasche in jedes Medaillon schneiden, salzen und pfeffern und mit den Oliven füllen. Mit einem Zahnstocher verschließen. Außen würzen und in einer heißen Pfanne auf jeder Seite anbraten. In einem auf 180 °C vorgeheizten Ofen ca. 7 Minuten garen. Die Sahne in einem kleinen Topf aufkochen lassen, Senf, Rotwein und Zwiebeln hinzufügen und mit Salz und Pfeffer abschmecken.

Die Medaillons halbieren und mit Reis und Senfsauce servieren. Mit Salat garnieren.

4 médaillons de porc, de chacun 120 g,
nettoyés
4 c. à soupe d'olives vertes dénoyautées
4 c. à soupe d'olives noires dénoyautées
Sel, poivre

240 ml de crème
4 c. à soupe de moutarde
100 ml de vin rouge
6 c. à soupe d'oignons à cocktail au vinaigre
Sel, poivre
Riz
Salade

Faire une incision dans chaque médaillon, saler, poivrer et garnir d'olives. Fermer avec un cure-dent. Assaisonner à l'extérieur et faire rôtir chaque côté dans une poêle chaude. Cuire pendant environ 7 minutes dans un four préchauffé à 180 °C. Amener la crème à ébullition dans une petite casserole, ajouter la moutarde, le vin rouge et les oignons et saler et poivrer.

Diviser les médaillons en deux et servir avec du riz et de la sauce à la moutarde. Garnir de salade.

4 medallones de cerdo, de 120 g cada uno,
limpios
4 cucharadas de aceitunas verdes deshuesadas
4 cucharadas de aceitunas negras deshuesadas
Sal, pimienta

240 ml de nata
4 cucharadas de mostaza
100 ml de vino tinto
6 cucharadas de cebollitas en salmuera
Sal, pimienta
Arroz
Hojas de lechuga

Haga una incisión profunda en cada medallón, salpiméntelas y rellénelas con las aceitunas. Ciérrelas después con un palillo. Salpimiente los medallones por fuera y áselos en una sartén caliente por los dos lados. Continúe asándolos en un horno precalentado a 180 °C durante 7 minutos. Cueza en una cazuela pequeña la nata, añada la mostaza, el vino tinto y la cebolla y salpimiente al gusto.

Corte los medallones en mitades y sírvalos acompañados de arroz y salsa de mostaza. Adorne con lechuga.

4 medaglioni di maiale da 120 g l'uno, puliti
4 cucchiai di olive verdi snocciolate
4 cucchiai di olive nere snocciolate

Sale, pepe

240 ml di panna
4 cucchiai di senape
100 ml di vino rosso
6 cucchiai di cipolline sottaceto
Sale, pepe
Riso
Insalata verde

Incidete i medaglioni aprendoli a tasca, salateli e pepateli e farciteli con le olive. Chiudeteli con uno stecchino. Conditeli all'esterno e fateli rosolare da ogni lato in una padella bollente. Fateli cuocere in forno preriscaldato a 180 °C per ca. 7 minuti. Portate ad ebollizione la panna in un pentolino, aggiungete la senape, il vino rosso e le cipolline e correggete di sale e pepe.

Dividete i medaglioni a metà e servite con riso e salsa alla senape. Guarnite con insalata.

La Perle de Prague

Design: Frank O. Gehry, Vlado Milunič, Tereza Richterová,
Franck Fonteyne | Chef: Milan Mutka

Rašínovo nábřeží 80 | 120 00 Prague | Prague 2
Phone: +420 221 984 160
www.laperle.cz | info@laperle.cz
Subway: Karlovo náměstí
Opening hours: Tue–Sat lunch noon to 2 pm, Mon–Sat dinner 7 pm to 10:30 pm,
Sunday closed
Average price: Czk 1500
Cuisine: French

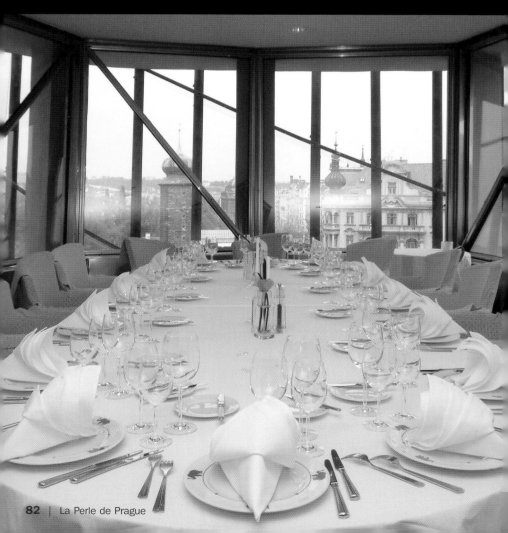

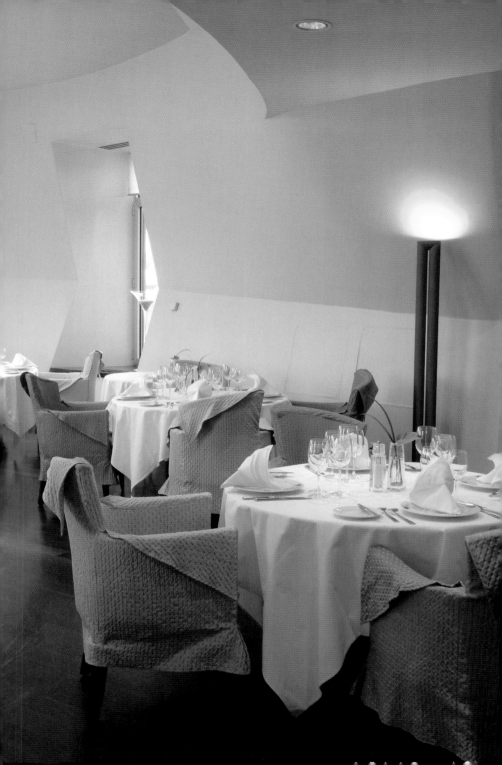

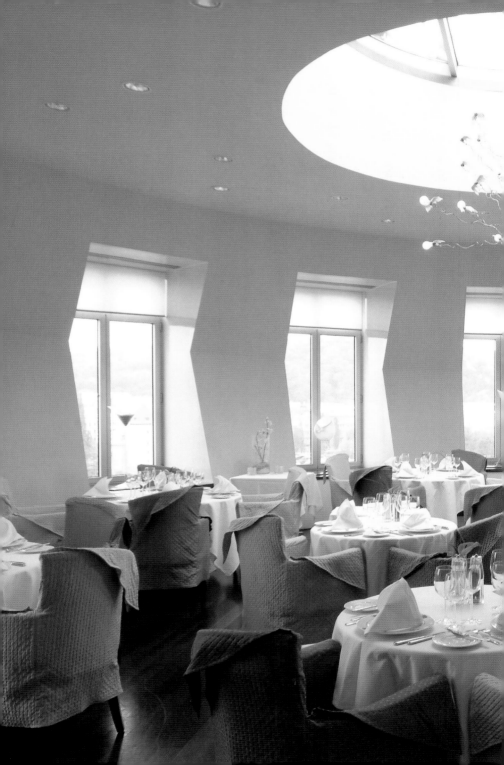

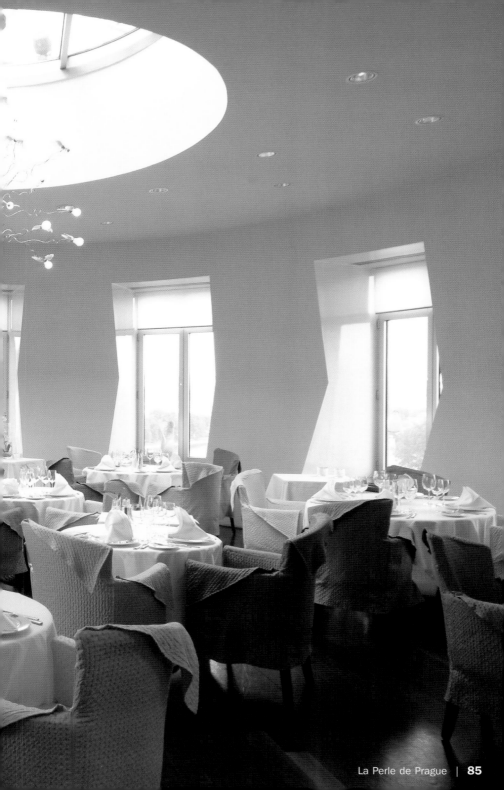

Duck Breasts

with Artichokes and Roast Potatoes

Entenbrust mit Artischocken und gerösteten Kartoffeln

Filets de canard aux artichauts et aux pommes de terre rissolées

Pechuga de pato con alcachofas y patatas asadas

Petto di anatra con carciofi e patate arrosto

4 duck breasts
8 small potatoes
2 large red onions
120 ml raspberry vinegar
100 ml Cassis liqueur
2 artichoke hearts
120 ml white wine
Fresh basil
Fresh coriander
2 cloves of garlic
Lemon juice
240 ml Port
1 tsp saffron
4 tbsp cold butter
Salt, pepper, sugar
Olive oil for frying
4 grilled tomatoes
4 sprigs of thyme

Chop the potatoes in half and bake in olive oil until cooked. Cut the artichoke hearts into small triangles and steam in olive oil with the white wine, basil, coriander, garlic and lemon juice. Chop the onions into thin slices and sauté with the vinegar and Cassis until soft. Season all the side dishes with salt and pepper. Criss-cross the fatty side of the duck breasts, season the meaty side with salt and pepper and sear on the fatty side for approx. 3 minutes. Place in a pre-heated oven at 350 °F for 10 minutes.

Heat the port, add the saffron and allow to simmer for 15 minutes. Just before serving, stir in the butter to thicken the sauce. Season with salt, pepper and sugar. Serve with grilled tomato and garnish with a sprig of thyme.

4 Entenbrüste
8 kleine Kartoffeln
2 große rote Zwiebeln
120 ml Himbeeressig
100 ml Cassislikör
2 Artischockenherzen
120 ml Weißwein
Frischer Basilikum
Frischer Koriander
2 Knoblauchzehen
Zitronensaft
240 ml Portwein
1 TL Safran
4 EL kalte Butter
Salz, Pfeffer, Zucker
Olivenöl zum Braten
4 Grilltomaten
4 Thymianzweige

Die Kartoffeln halbieren und in Olivenöl durchgaren. Artischockenherzen in kleine Dreiecke schneiden und in Olivenöl mit Weißwein, Basilikum, Koriander, Knoblauch und Zitronensaft dünsten. Die Zwiebeln in dünne Scheiben schneiden und mit Essig und Likör weich schmoren. Alle Beilagen mit Salz und Pfeffer würzen. Die Fettseite der Entenbrüste kreuzweise einschneiden, die Fleischseite mit Salz und Pfeffer würzen und auf der Fettseite ca. 3 Minuten scharf anbraten. Für 10 Minuten in einen auf 180 °C vorgeheizten Ofen geben.

Portwein aufkochen, Safran zugeben und 15 Minuten köcheln lassen. Kurz vor dem Servieren zum Andicken die Butter unterrühren. Mit Salz, Pfeffer und Zucker würzen. Entenbrüste, Beilagen und Sauce anrichten, mit Grilltomate und Thymianzweig garnieren.

4 filets de canard
8 petites pommes de terre
2 gros oignons rouges
120 ml de vinaigre de framboise
100 ml de liqueur de cassis
2 cœurs d'artichaut
120 ml de vin blanc
Basilic frais
Coriandre fraîche
2 gousses d'ail
Jus de citron
240 ml de Porto
1 c. à café de safran
4 c. à soupe de beurre froid
Sel, poivre, sucre
Huile d'olive à frire
4 tomates grillées
4 branches de thym

Diviser les pommes de terre en deux et les cuire dans l'huile d'olive. Couper les cœurs d'artichaut en petits triangles et faire étuver dans l'huile d'olive avec le vin blanc, le basilic, la coriandre, l'ail et le jus de citron. Couper les oignons en fines tranches et les attendrir avec le vinaigre et la liqueur. Saler et poivrer toute la garnitures. Faire des incisions dans le côté gras des filets de canard, saler et poivrer le côté chair et rôtir fortement du côté gras pendant environ 3 minutes. Mettre au four préchauffé à 180 °C pendant 10 minutes.
Amener le Porto à ébullition, ajouter le safran et faire mijoter pendant 15 minutes. Juste avant de servir, incorporer le beurre pour épaissir. Assaisonner de sel, de poivre et de sucre. Disposer sur l'assiette les filets de canard, la garniture et la sauce, décorer avec la tomate grillée et une branche de thym.

4 pechugas de pato
8 patatas pequeñas
2 cebollas rojas grandes
120 ml de vinagre de frambuesa
100 ml de licor de cassis
2 corazones de alcachofa
120 ml de vino blanco
Albahaca fresca
Cilantro fresco
2 dientes de ajo
Zumo de limón
240 ml de vino de Oporto
1 cucharadita de azafrán
4 cucharadas de mantequilla fría
Sal, pimienta, azúcar
Aceite de oliva para freír
4 tomates de parrilla
4 ramitas de tomillo

Corte las patatas y rehóguelas en aceite de oliva. Corte los corazones de las alcachofas en tres trozos y rehóguelos en aceite de oliva junto con el vino blanco, la albahaca, el cilantro, el ajo y el zumo de limón. Corte la cebolla en finas rodajas y rehóguelas hasta que estén blandas en el vinagre y el licor. Condimente los acompañamientos con sal y pimienta. Haga incisiones cruzadas en el lado de la grasa de las pechugas, salpimiente el lado de la carne y fría las pechugas a fuego fuerte por el lado de la grasa durante 3 minutos. Áselas después en un horno precalentado a 180 °C durante 10 minutos.

Lleve el Oporto a ebullición, añada el azafrán y deje que cueza durante 15 minutos. Antes de servir añada la mantequilla para espesar la salsa y remueva. Condiméntela con la sal, la pimienta y el azúcar. Ponga en los platos las pechugas, los acompañamientos y vierta por encima la salsa. Decore con los tomates y el tomillo y sirva.

4 petti di anatra
8 patate piccole
2 cipolle rosse grosse
120 ml di aceto di lampone
100 ml di liquore di cassis
2 cuori di carciofo
120 ml di vino bianco
Basilico fresco
Coriandolo fresco
2 spicchi d'aglio
Succo di limone
240 ml di vino porto
1 cucchiaino di zafferano
4 cucchiai di burro freddo
Sale, pepe, zucchero
Olio d'oliva per cuocere
4 pomodori grigliati
4 rametti di timo

Dividete le patate a metà e fatele cuocere bene nell'olio d'oliva. Tagliate i cuori di carciofo a triangolini e fateli stufare nell'olio d'oliva con vino bianco, basilico, coriandolo, aglio e succo di limone. Tagliate le cipolle a fette sottili e stufatele con aceto e liquore finché diventeranno morbide. Salate e pepate tutti i contorni. Incidete una croce sulla parte di grasso dei petti di anatra, salate e pepate la parte di carne e fate rosolare bene la parte di grasso per ca. 3 minuti. Passate in forno preriscaldato a 180 °C per 10 minuti.

Portate ad ebollizione il vino porto, aggiungete lo zafferano e lasciate crogiolare per 15 minuti. Poco prima di servire, incorporatevi il burro per addensare. Salate, pepate e zuccherate. Servite i petti di anatra con i contorni e la salsa, guarnite con pomodoro grigliato e rametto di timo.

Lary Fary

Design: Ota Blaha | Chef: David Karoch
Owner: Kolkovna Group a.s.

Dlouhá 30 | 110 00 Prague | Prague 1
Phone: +420 222 320 154
www.kolkovna-group.cz | info@laryfary.cz
Subway: Náměstí Republiky
Opening hours: Every day 11 am to midnight
Average price: Czk 850
Cuisine: International, Asian

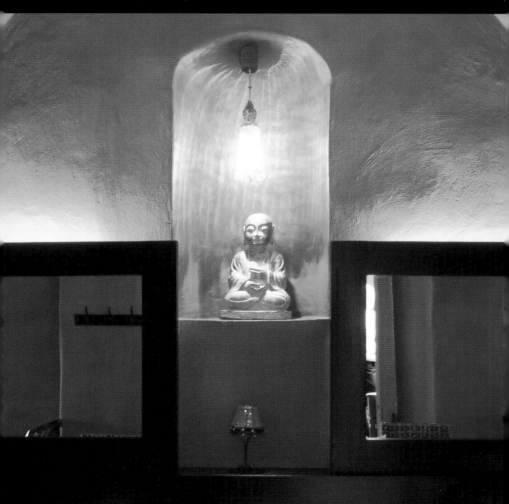

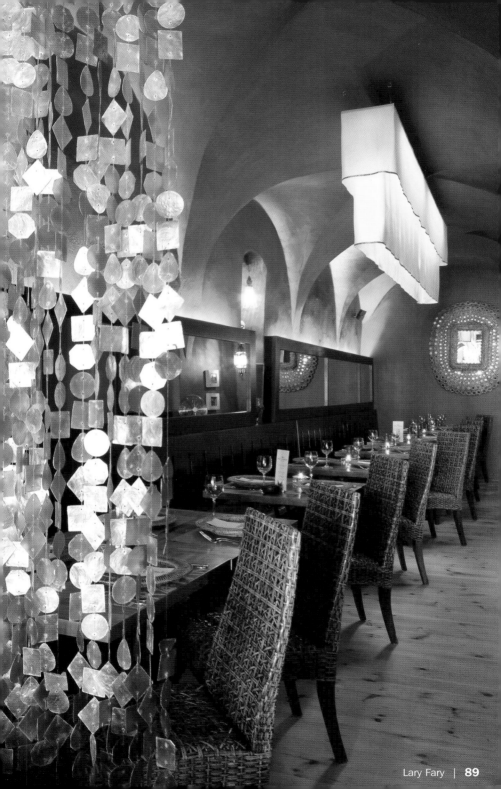

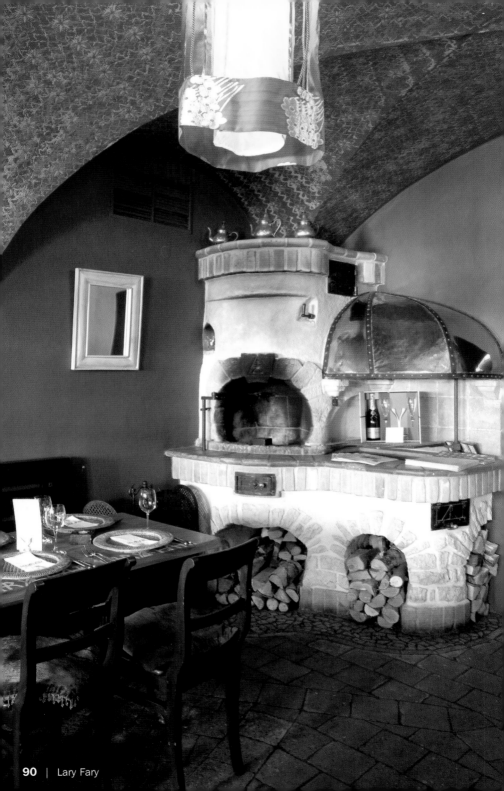

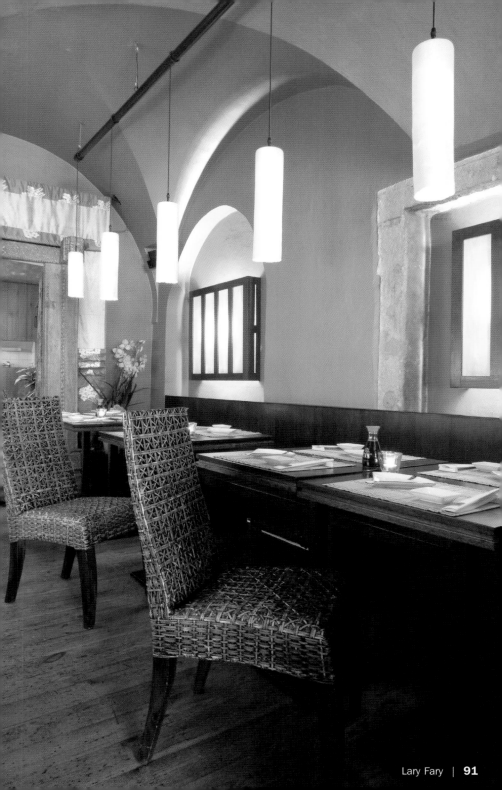

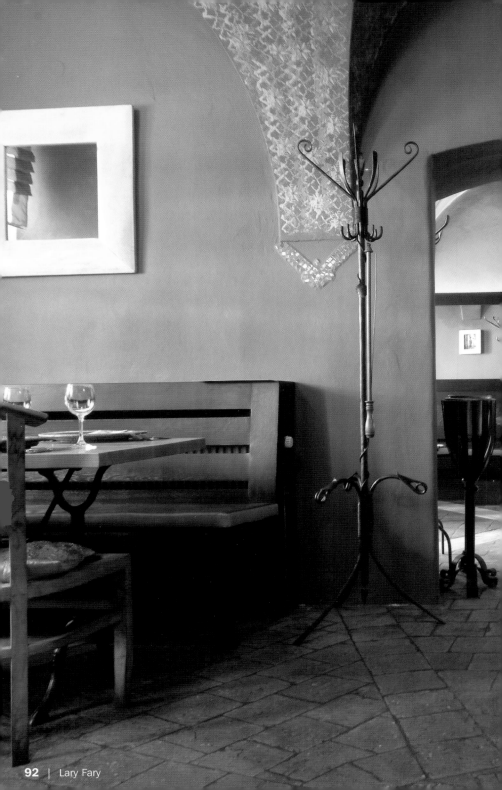

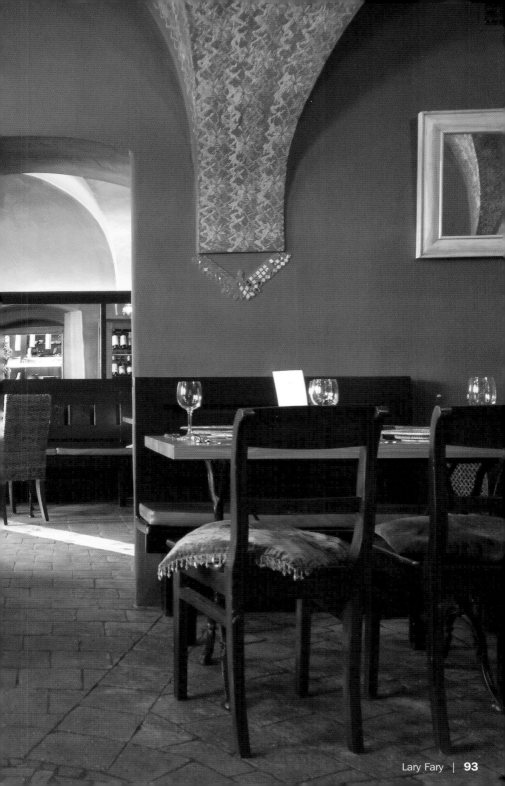

PATRIOT-X

Design: Dagmar and Martin Janata | Chef: Pavel Ouhrabka
Owner: Dagmar Janatová

V Celnici 3 | 110 00 Prague | Prague 1
Phone: +420 224 235 158
www.patriot-x.cz | info@patriot-x.cz
Subway: Náměstí Republiky
Opening hours: Every day 10 am to midnight
Average price: Czk 457
Cuisine: Czech
Special features: Kid-friendly, gourmet club, gallery

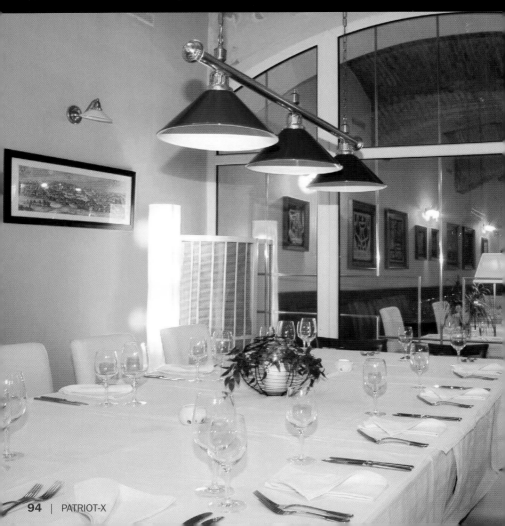

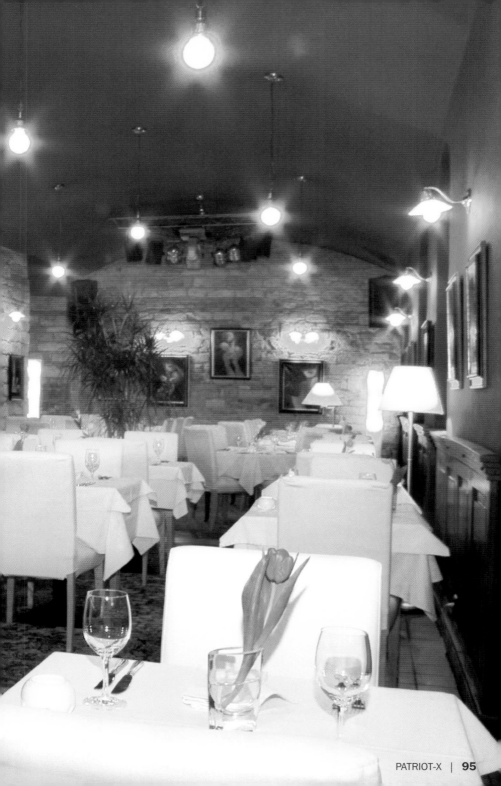

Marinated
Venison Fillets
with Carrots and Mushrooms

Marinierte Wildfilets mit Möhren und Pilzen

Filets de gibier marinés aux carottes et aux champignons

Filetes de caza marinados con judías y setas

Filetti di selvaggina marinati con carote e funghi

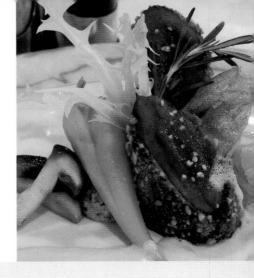

4 fillets of venison, 5 oz each
Marinade: 2 tbsp freshly chopped rosemary, 2 tbsp freshly chopped thyme, 4 tbsp truffle oil, 4 tbsp Madeira

Salt, pepper, 4 tbsp flour, 2 eggs, 3 1/2 oz breadcrumbs, 3 1/2 oz ground walnuts, frying oil

8 small carrots, peeled and cut in half lengthways, 2 tbsp butter, 2 tbsp sugar, 6 oz mushrooms, 2 tbsp olive oil, 3 tbsp parsley, chopped, salt, pepper, 4 egg yolks, 20 ml chicken stock, 40 ml Cognac

Marinate the venison for 12 hours. Dry with a paper towel, season and coat in the flour, egg and breadcrumb-walnut mixture. Sear in hot oil for 2 minutes on each side, then place in a 350 °F oven for approx. 15 minutes. Sauté the carrots "al dente" in hot butter, season with salt and sugar. Fry the mushrooms in olive oil, add parsley and season with salt and pepper. Over a pan of simmering water, whisk the egg yolks, chicken stock and Cognac to a light foam and season. Arrange the mushrooms on the center of a plate, place the venison fillet on top and decorate with carrots and the foam mixture. Serve immediately.

4 Wildfilets, je 150 g
Marinade: 2 EL frisch gehackter Rosmarin, 2 EL frisch gehackter Thymian, 4 EL Trüffelöl, 4 EL Madeira

Salz, Pfeffer, 4 EL Mehl, 2 Eier, 100 g Semmelbrösel, 100 g gemahlene Walnüsse, Öl zum Braten

8 kleine Möhren, geschält und längs halbiert, 2 EL Butter, 2 EL Zucker, 180 g Pilze, 2 EL Olivenöl, 3 EL Petersilie, gehackt, Salz, Pfeffer, 4 Eigelb, 20 ml Geflügelbrühe, 40 ml Cognac

Das Wild für 12 Stunden marinieren. Mit einem Papiertuch abtrocknen, salzen und pfeffern und in Mehl, Eiern und Semmelbrösel-Walnuss-Mix wenden. In heißem Öl von jeder Seite 2 Minuten braten, dann für ca. 15 Minuten in einen 180 °C heißen Ofen geben. Möhren in heißer Butter bissfest garen, mit Salz und Zucker würzen. Pilze in Olivenöl braten, Petersilie dazugeben und mit Salz und Pfeffer würzen. Eigelbe, Geflügelbrühe und Cognac in einem warmen Wasserbad schaumig schlagen und mit Salz und Pfeffer würzen. Die Pilze in die Mitte des Tellers geben, das Wildfilet darauf legen und mit Möhren und Eischaum garnieren. Sofort servieren.

4 filets de gibier, de 150 g chacun
Marinade : 2 c. à soupe de romarin fraîchement
haché, 2 c. à soupe de thym fraîchement haché,
4 c. à soupe d'huile de truffe, 4 c. à soupe de
Madère

Sel, poivre, 4 c. à soupe de farine, 2 œufs,
100 g de chapelure, 100 g de noix moulues,
de l'huile à frire

8 petites carottes, épluchées et coupées en deux
dans la longueur, 2 c. à soupe de beurre,
2 c. à soupe de sucre, 180 g de champignons,
2 c. à soupe d'huile d'olive, 3 c. à soupe de per-
sil, haché, sel, poivre, 4 jaunes d'œuf, 20 ml de
bouillon de volaille, 40 ml de Cognac

Laisser mariner le gibier pendant 12 heures. Sécher
à l'aide d'un essuie-tout en papier, saler et poivrer
et rouler dans la farine, puis dans les œufs battus et
ensuite dans un mélange de chapelure et de noix.
Faire frire dans de l'huile chaude de chaque côté
pendant 2 minutes, puis mettre pendant environ
15 minutes dans un four préchauffé à 180 °C.
Faire cuire les carottes dans du beurre chaud sans
qu'elles ne deviennent trop tendres, saler et poivrer.
Faire revenir les champignons dans l'huile d'olive,
ajouter le persil, puis le sel et le poivre. Battre les
jaunes d'œuf, le bouillon de volaille et le cognac
dans un bain-marie chaud pour obtenir un mélange
mousseux et saler et poivrer. Disposer les champi-
gnons au milieu de l'assiette, ajouter dessus le filet
de gibier et garnir avec les carottes et la mousse
d'œufs. Servir tout de suite.

4 filetes de caza, de 150 g cada uno
Marinada: 2 cucharadas de romero recién picado,
2 cucharadas de tomillo recién picado, 4 cucha-
radas de aceite de trufa, 4 cucharadas de
Madeira

Sal, pimienta, 4 cucharadas de harina, 2 huevos,
100 g migas de pan, 100 g nueces molidas,
Aceite para freír

8 zanahorias pequeñas, peladas y en mitades
longitudinales, 2 cucharadas de mantequilla,
2 cucharadas de azúcar, 180 g de setas,
2 cucharadas de aceite de oliva, 3 cucharadas de
perejil, picado, sal, pimienta, 4 yemas, 20 ml de
caldo de ave, 40 ml de brandy

Marine la caza durante 12 horas. Seque los file-
tes con papel de cocina y salpimiéntelos. Mezcle
la harina con los huevos, las migas de pan y las
nueces molidas. Reboce la carne en la mezcla.
Fría los filetes en una sartén con aceite caliente
durante 2 minutos por cada lado. Introdúzcalos
después en un horno precalentado a 180 °C y
ase la carne durante 15 minutos aproximada-
mente. Rehogue la zanahoria en mantequilla
caliente hasta que esté en su punto y sazone con
sal y azúcar. Sofría las setas en aceite de oliva,
añada el perejil y salpimiente. Bata al baño maría
la yema, el caldo y el brandy hasta que la mezcla
sea espumosa. Salpimiente. Ponga las setas en
el centro de los platos, coloque encima los filetes
y adorne con la zanahoria y la espuma del huevo.
Sirva inmediatamente.

4 filetti di selvaggina da 150 g l'uno
Marinata: 2 cucchiai di rosmarino appena tritato,
2 cucchiai di timo appena tritato, 4 cucchiai di
olio tartufato, 4 cucchiai di vino Madeira

Sale, pepe, 4 cucchiai di farina, 2 uova,
100 g di pangrattato, 100 g di noci tritate,
Olio per cuocere

8 carote piccole, mondate e divise a metà per il
lungo, 2 cucchiai di burro, 2 cucchiai di zucchero,
180 g di funghi, 2 cucchiai di olio d'oliva, 3 cucchiai
di prezzemolo tritato, Sale, pepe, 4 tuorli d'uovo,
20 ml di brodo di pollo, 40 ml di cognac

Fate marinare la selvaggina per 12 ore. Asciugate
con carta da cucina assorbente, salate e pepate
e passate nella farina, nelle uova e nel miscuglio
di pangrattato e noci. Fate cuocere in olio bollente
per 2 minuti per lato, passate in forno caldo a
180 °C per ca. 15 minuti. Fate cuocere le carote
al dente nel burro bollente, salate e zuccherate.
Soffriggete i funghi nell'olio d'oliva, aggiungete il
prezzemolo, salate e pepate. In un bagnomaria
caldo montate i tuorli d'uovo con il brodo di pollo
e il cognac, salate e pepate. Mettete i funghi al
centro del piatto, disponetevi sopra il filetto di
selvaggina e guarnite con carote e spuma d'uovo.
Servite subito.

Pravda Restaurant

Chef: Jaroslav Reichardt | Owner: Tommy Sjöö

Pařížská 17 | 110 00 Prague | Prague 1
Phone: +420 222 326 203
www.pravda.bacchusgroup.cz | office@bacchusgroup.cz
Subway: Staroměstská
Opening hours: Every day 11:30 am to 1 am
Average price: Czk 1500
Cuisine: International

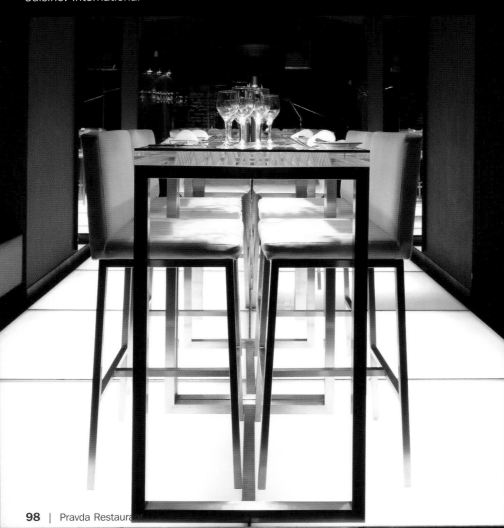

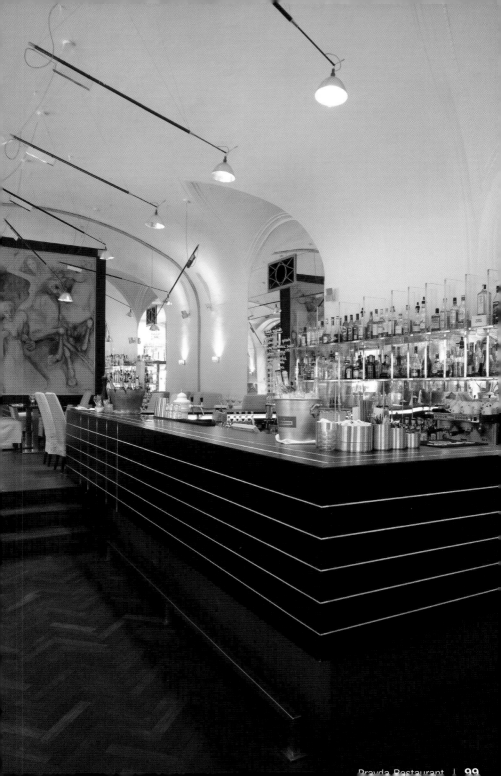

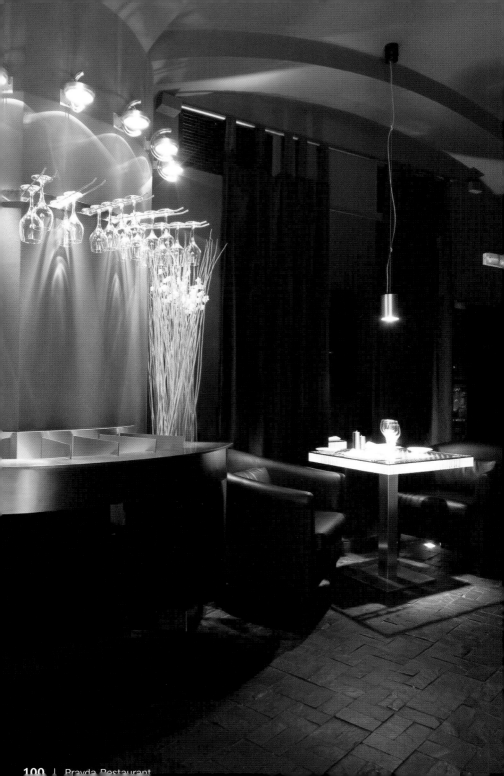

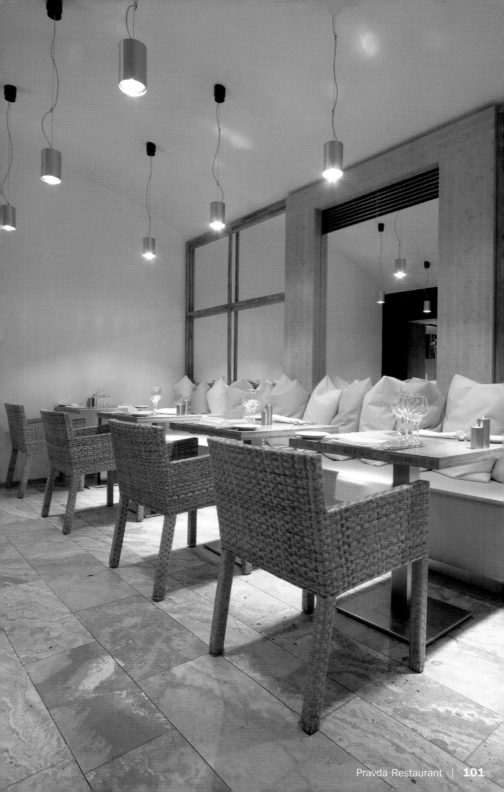

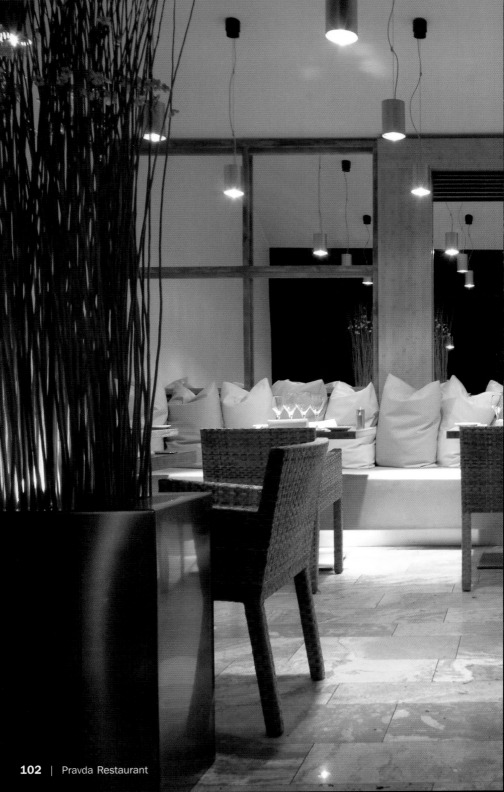

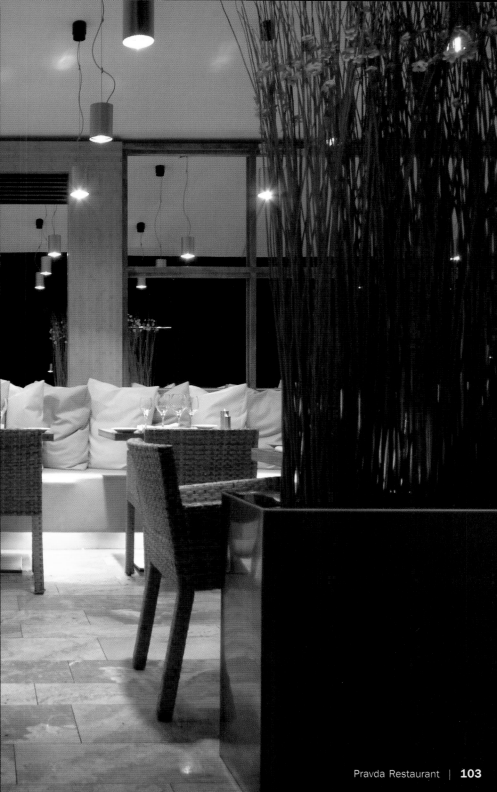

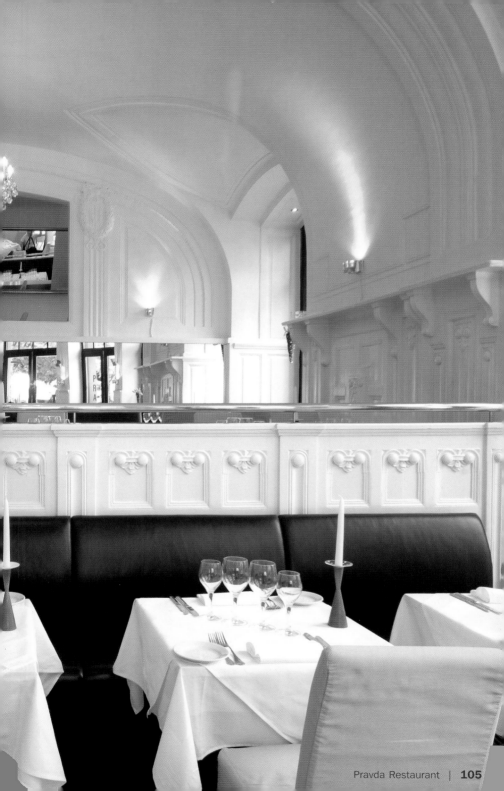

Resto Café Patio

Design: Vladislava Loudová | Chef: Martin Ondík
Owner: Eureca shops s.r.o.

Haštalská 18 | 110 00 Prague | Prague 1
Phone: +420 224 819 767
www.patium.com | resto@patium.com
Subway: Náměstí Republiky
Opening hours: Mon–Sat 11 am to 11 pm, Sun 5 pm to 11 pm
Average price: Czk 230
Cuisine: International
Special features: Summer garden restaurant, open kitchen

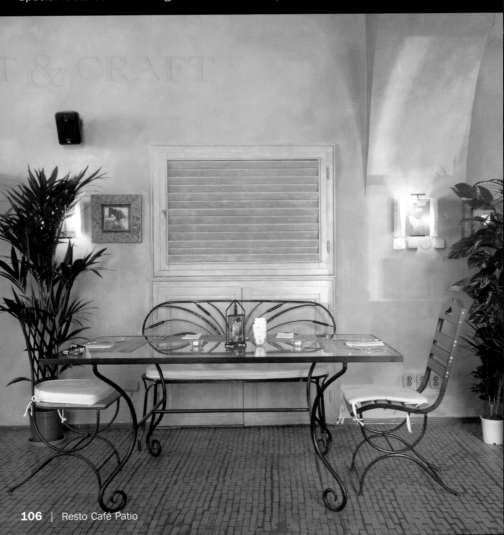

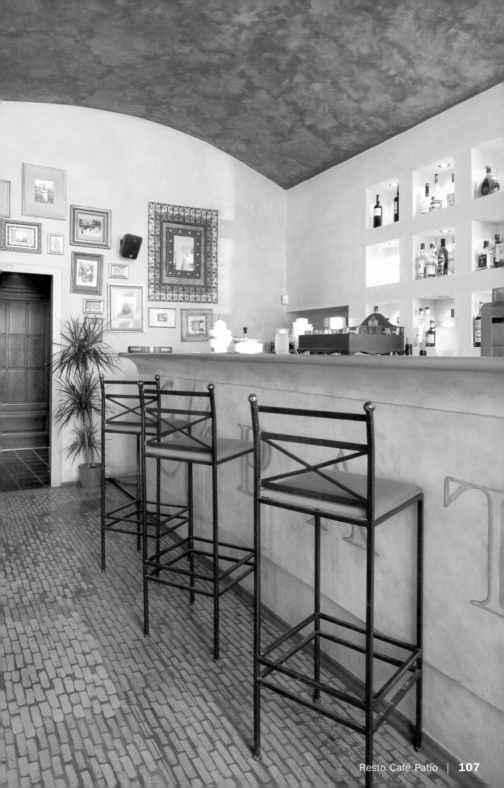

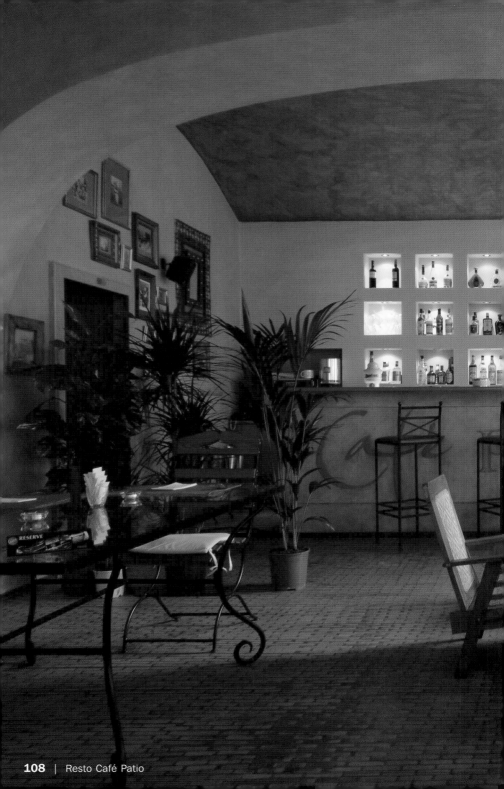

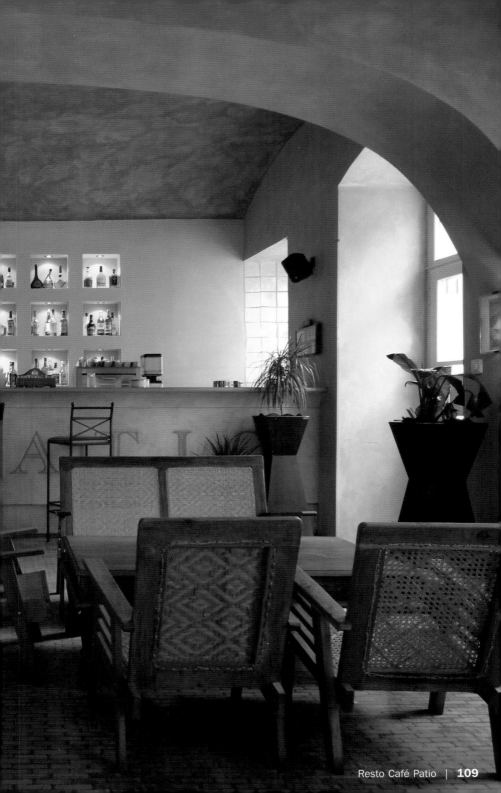

Šípek Bistrot

Design: Bořek Šípek | Chef: Miroslav Kalina
Owner: Bořek Šípek

Valentinská 57/9 | 110 00 Prague | Prague 1
Phone: +420 222 323 948
www.sipekbistrot.com | bistrot@sipekbistrot.com
Subway: Staroměstská
Opening hours: Mon–Sat 11 am to 11 pm
Average price: Czk 390
Cuisine: French

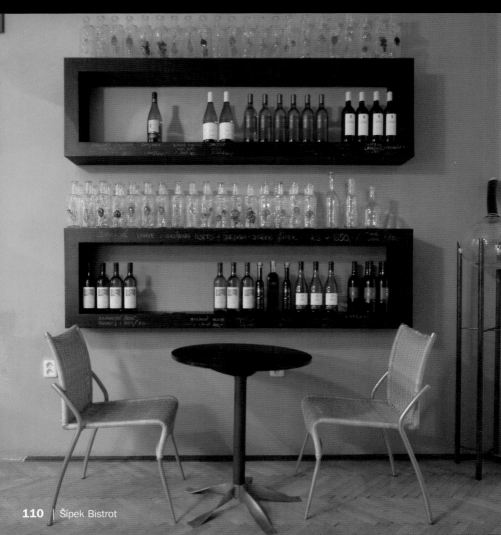

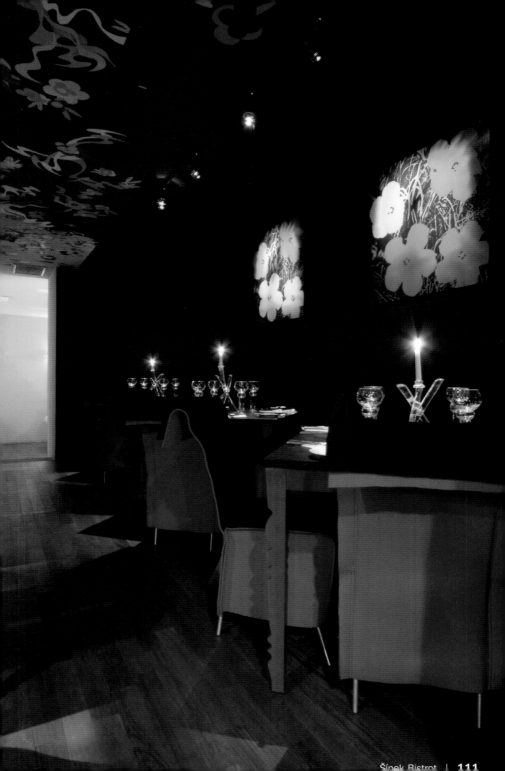

Pigeon Breasts
with Pea Purée

Taubenbrüste mit Erbsenpüree

Filets de pigeons à la purée de petits pois

Pechugas de paloma con puré de guisantes

Petti di piccione con purea di piselli

4 pigeon breasts
4 portions of foie gras, 1 oz each
4 slices Serrano bacon
Salt, pepper
Flour
2 eggs, lightly beaten
3 tbsp pistachios, ground
3 tbsp walnuts, ground
Vegetable oil for frying

10 oz fresh peas (reserve some for decoration)
2 tbsp butter
100 ml chicken stock

Stuff pigeon breasts with the foie gras and bacon, fastening with a toothpick. Season with salt and pepper and toss in flour, egg and nuts. Lightly brown the meat on each side in hot vegetable oil in a frying pan and bake in a 350 °F oven for approx. 5–7 minutes.

Sauté the peas in hot butter, add the chicken stock and allow to simmer for 5 minutes. Mix in a blender until smooth. Season to taste.

Cut each pigeon breast in half and arrange on 4 plates with the pea purée and dark juices from the fried pigeons. Garnish with the reserved peas.

4 Taubenbrüste
4 Stück Stopfleber, je 30 g
4 Scheiben Serranoschinken
Salz, Pfeffer
Mehl
2 Eier, leicht geschlagen
3 EL Pistazien, gemahlen
3 EL Walnüsse, gemahlen
Pflanzenöl zum Braten

300 g frische Erbsen (einige zur Dekoration zurückbehalten)
2 EL Butter
100 ml Geflügelbrühe

Die Taubenbrüste mit Leber und Schinken füllen, mit einem Zahnstocher verschließen. Mit Salz und Pfeffer würzen und in Mehl, Eiern und Nüssen wälzen. In einer Pfanne in heißem Pflanzenöl auf jeder Seite leicht anbraten und in einem 180 °C heißen Ofen für ca. 5–7 Minuten garen.

Erbsen in heißer Butter anschwitzen, Geflügelbrühe dazugeben und für 5 Minuten köcheln lassen. In einem Mixer glattmixen. Abschmecken.

Jede Taubenbrust halbieren und mit dem Erbsenpüree und der dunklen Jus von den gebratenen Tauben auf vier Tellern anrichten. Mit den übrigen Erbsen garnieren.

4 filets de pigeons
4 morceaux de foie gras, de 30 g chacun
4 tranches de jambon de Serrano
Sel, poivre
Farine
2 œufs, légèrement battus
3 c. à soupe de pistaches, moulues
3 c. à soupe de noix, moulues
Huile végétale à frire

300 g de petits pois frais (après cuisson, en mettre quelques-uns de côté pour la décoration)
2 c. à soupe de beurre
100 ml de bouillon de volaille

Garnir les filets de pigeons de foie et de jambon, fermer avec un cure-dent. Saler, poivrer et rouler dans la farine, les œufs et les noix. Faire rôtir légèrement de chaque côté dans une poêle avec de l'huile végétale chaude et cuire dans un four préchauffé à 180 °C pendant 5–7 minutes.

Faire suer les petits pois dans le beurre chaud, ajouter le bouillon de volaille et laisser mijoter pendant 5 minutes. Passer au mixer. Assaisonner.

Diviser en deux chaque filet de pigeon et les répartir sur quatre assiettes avec la purée de petits pois et le jus foncé des pigeons rôtis. Garnir avec les petits pois restants.

4 pechugas de paloma
4 foie gras, de 30 g cada uno
4 lonchas de jamón serrano
Sal, pimienta
Harina
2 huevos, ligeramente batidos
3 cucharadas de pistachos, molidos
3 cucharadas de nueces, molidas
Aceite vegetal para freír

300 g de guisantes frescos (reserve algunos para decorar)
2 cucharadas de mantequilla
100 ml de caldo de ave

Rellene las pechugas de paloma con el foie gras y el jamón y ciérrelas con un palillo de madera. Salpiméntelas y rebócelas después en la harina, el huevo, las nueces y los pistachos. Caliente en una sartén el aceite vegetal y fría las pechugas ligeramente por cada lado. Áselas después en un horno a 180 °C entre 5-7 minutos.

Rehogue los guisantes en mantequilla caliente, añada el caldo de ave y deje que hierva durante 5 minutos. Pase los guisantes por el pasapurés y salpimiente al gusto.

Corte las pechugas en mitades y colóquelas en cuatro platos junto con el puré de guisantes y el jugo oscuro expulsado por las pechugas al freírlas. Decore con los guisantes.

4 petti di piccione
4 pezzi di fegato grasso da 30 g l'uno
4 fette di prosciutto Serrano
Sale, pepe
Farina
2 uova sbattute poco
3 cucchiai di pistacchi tritati
3 cucchiai di noci tritate
Olio vegetale per cuocere

300 g di piselli freschi (lasciarne alcuni per decorare)
2 cucchiai di burro
100 ml di brodo di pollo

Farcite i petti di piccione con fegato e prosciutto, chiudeteli con uno stecchino. Salateli e pepateli e passateli nella farina, nelle uova e nelle noci. Fateli rosolare leggermente da ogni lato in una padella con olio vegetale bollente e continuate a farli cuocere in forno caldo a 180 °C per ca. 5–7 minuti.

Fate dorare i piselli nel burro bollente, aggiungete il brodo di pollo e lasciate crogiolare per 5 minuti. Riducete in purea in un frullatore. Correggete di sapore.

Dividete i petti di piccione a metà e disponeteli su quattro piatti con la purea di piselli e il fondo scuro di cottura dei piccioni. Guarnite con i piselli tenuti da parte.

Square

Design: Barbora Škorpilova | Chef: Miloslav Fojt
Owner: Nils Jebens

Malostranské náměstí 5/28 | 118 00 Prague | Prague 1
Phone: +420 296 826 104
www.kampagroup.com | kontakt@squarerestaurant.cz
Subway: Malostranské náměstí
Opening hours: Every day 8 am to 1 am
Average price: Czk 235
Cuisine: Italian, Spanish

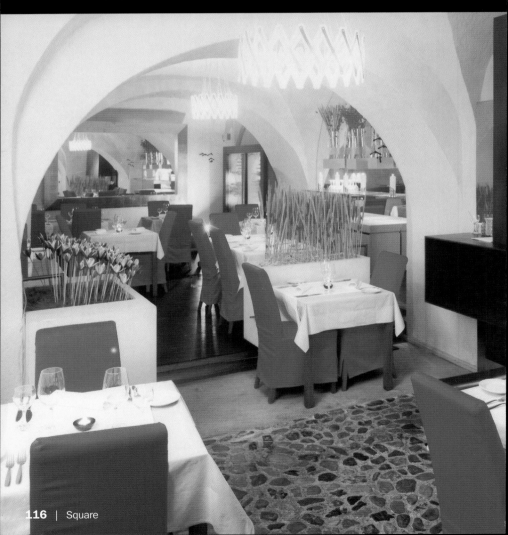

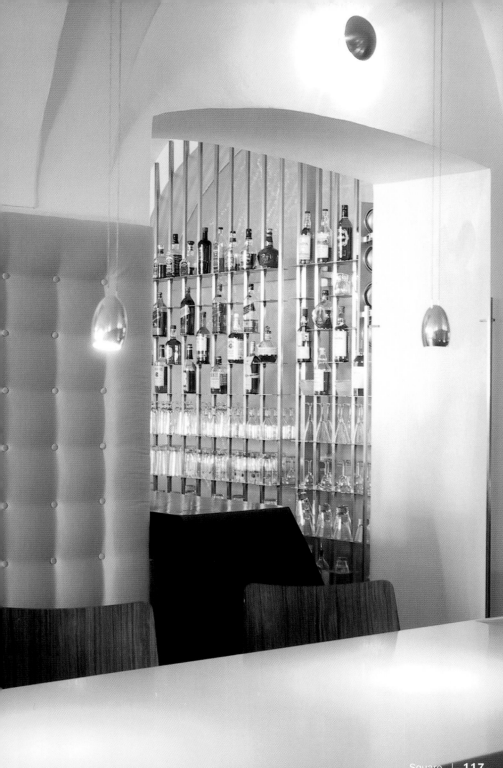

Grilled Lobster
with Tarragon and Garlic

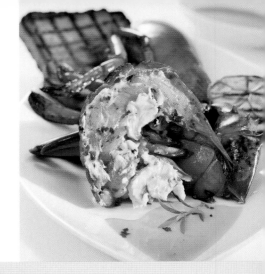

Gegrillter Hummer mit Estragon
und Knoblauch

Homards grillés à l'estragon et à l'ail

Langosta a la parrilla con estragón y ajo

Astice alla piastra con dragoncello e aglio

2 lobsters, about 2 lb each
6 oz butter
3 garlic cloves, chopped
2 tbsp tarragon, chopped
Pinch of cayenne pepper
Juice of 1 lemon
Salt, pepper

4 slices toasted white bread
4 tbsp tarragon oil
Lettuce

Mix the butter at room temperature in a small bowl with garlic, tarragon, cayenne pepper and lemon juice. Cut the lobsters in half lengthways. Season with salt and pepper and brush the meat with herb-butter. Place the lobster in a frying pan, fleshy side down and steam for approx. 7 minutes at medium heat. Turn over and repeat.

Serve the lobsters, fleshy-side up, with a drizzle of tarragon oil, toasted white bread triangles and a green salad.

2 Hummer, jeweils ca. 1 kg
180 g Butter
3 Knoblauchzehen, gehackt
2 EL Estragon, gehackt
Prise Cayennepfeffer
Saft einer Zitrone
Salz, Pfeffer

4 Scheiben getoastetes Weißbrot
4 EL Estragonöl
Blattsalat

Butter in Raumtemperatur mit Knoblauch, Estragon, Cayennepfeffer und Zitronensaft in einer kleinen Schüssel vermischen. Die Hummer der Länge nach zerteilen. Mit Salz und Pfeffer würzen und mit der Kräuterbutter bestreichen. Den Hummer in eine Pfanne geben, Fleischseite nach unten, und bei mittlerer Hitze ca. 7 Minuten dämpfen. Umdrehen und wiederholen.

Die Hummer, Fleischseite nach oben, mit etwas Estragonöl beträufeln und mit Weißbrotecken und Blattsalat servieren.

2 homards, de chacun 1 kg environ
180 g de beurre
3 gousses d'ail, hachées
2 c. à soupe d'estragon, haché
Une pincée de poivre de Cayenne
Le jus d'un citron
Sel, poivre

4 tranches de pain blanc grillé
4 c. à soupe d'huile d'estragon
Salade

Mélanger dans un petit saladier le beurre à température ambiante avec l'ail, l'estragon, le poivre de Cayenne et le jus de citron. Diviser le homard dans le sens de la longueur. Saler et poivrer et recouvrir de beurre aux fines herbes. Mettre le homard dans une poêle, côté chair sur le feu, et étuver à feu moyen pendant 7 minutes environ. Retourner le homard et répéter le processus.

Arroser d'un peu d'huile d'estragon le homard, côté chair vers le haut, et servir avec du pain blanc et de la salade.

2 langostas, aprox. 1 kg cada una
180 g de mantequilla
3 dientes de ajo, picados
2 cucharadas de estragón, picado
Una pizca de cayena molida
El zumo de un limón
Sal, pimienta

4 rebanadas de pan blanco tostadas
4 cucharadas de aceite de estragón
Ensalada de lechuga

Mezcle en un cuenco pequeño la mantequilla a temperatura ambiente, el ajo, el estragón, la cayena y el zumo de limón. Corte las langostas por la mitad longitudinalmente. Salpimiéntelas y úntelas con la mantequilla de hierbas. Coloque las langostas en una sartén con el lado de la carne hacia abajo. Áselas a fuego medio durante 7 minutos aproximadamente. Dé la vuelta a las mitades y repita el proceso.

Coloque las mitades de langosta en los platos con los lados de la carne hacia arriba. Vierta por encima un poco de aceite de estragón y sirva con pan blanco y lechuga.

2 astici da 1 kg circa l'uno
180 g di burro
3 spicchi d'aglio tritati
2 cucchiai di dragoncello tritato
Pizzico di pepe di Caienna
Succo di un limone
Sale, pepe

4 fette di pane bianco tostato
4 cucchiai di olio al dragoncello
Insalata verde

In una ciotola piccola mescolate il burro a temperatura ambiente con aglio, dragoncello, pepe di Caienna e succo di limone. Tagliate gli astici nel senso della lunghezza. Salateli e pepateli e spalmatevi sopra il burro aromatizzato. Mettete l'astice in una padella con la parte di carne rivolta verso il basso, e fate cuocere a vapore a fuoco medio per ca. 7 minuti. Girate e ripetete.

Versate alcune gocce di olio al dragoncello sugli astici con la parte di carne rivolta verso l'alto e servite con pezzetti di pane bianco e insalata verde.

Terasa U Zlaté studně

Design: Roman Řezníček | Chef: Pavel Sapík
Owner: Roman Řezníček

U Zlaté studně 166/4 | 118 00 Prague | Prague 1
Phone: +420 257 533 322
www.terasauzlatestudne.cz | restaurant@zlatastudna.cz
Subway: Malostranské náměstí
Opening hours: Every day 7 am to 11 pm
Average price: Czk 1200
Cuisine: International
Special features: Terrace and restaurant with view over Prague

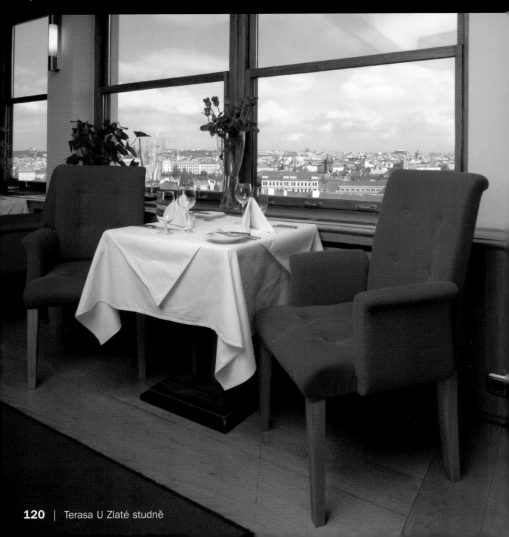

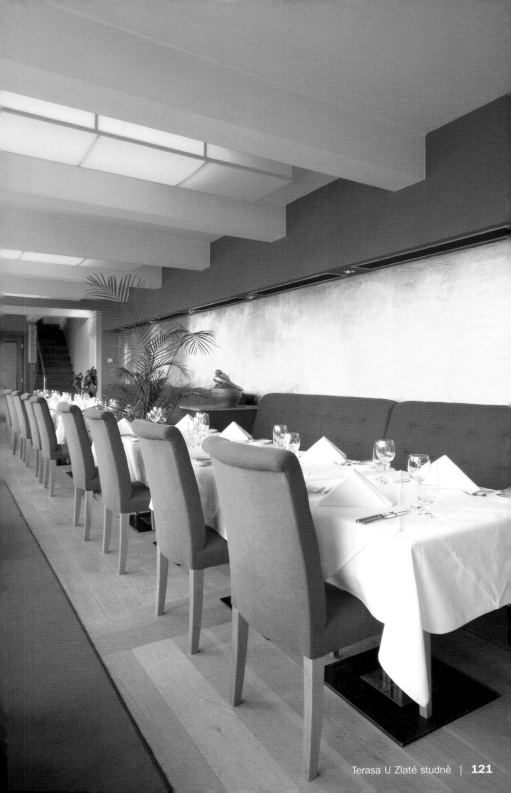

Tretter's New York Bar

Design: Michael Tretter | Chef: Petr Kymla
Owner: Michael Tretter

V Kolkovně 3 | 110 00 Prague | Prague 1
Phone: +420 224 811 165
www.tretters.cz | catering@tretters.cz
Subway: Staroměstská
Opening hours: Every day 7 pm to open end
Average price: Czk 130

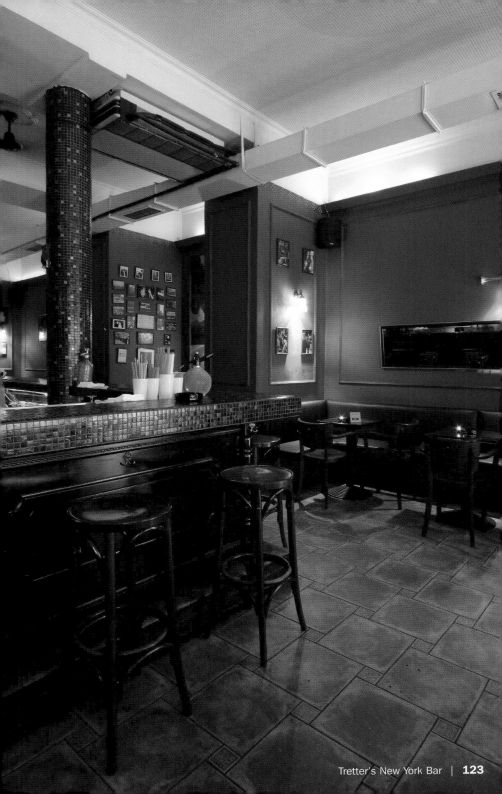

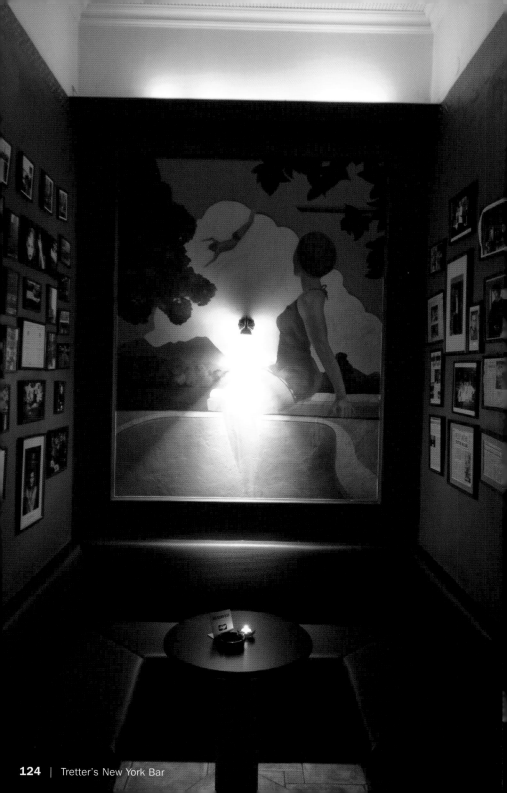

Caipikahlua
Cocktail

5 cl Kahlua
1 tbsp brown sugar
1 lime, quartered
1 cl lemon juice
Crushed ice
Straw

Place the lime and brown sugar in a glass and crush with a pestle. Add crushed ice, Kahlua and lemon juice and serve immediately with a straw.

5 cl Kahlua
1 EL brauner Zucker
1 Limette, geviertelt
1 cl Zitronensaft
Crusheis
Strohhalm

Limette und braunen Zucker in ein Glas geben und mit einem Stößel zerdrücken. Crusheis, Kahlua und Zitronensaft darauf geben und sofort mit einem Strohhalm servieren.

5 cl de Kahlua
1 c. à soupe de sucre brun
1 citron vert, coupé en quatre
1 cl de jus de citron
Glace pilée
Paille

Verser le citron vert et le sucre brun dans un verre et les écraser au pilon. Ajouter la glace pilée, le Kahlua et le jus de citron, puis servir immédiatement avec une paille.

5 cl Kahlua
1 cucharada de azúcar moreno
1 lima, en cuartos
1 cl de zumo de limón
Hielo picado
Pajita

Introduzca la lima y el azúcar moreno en un vaso y machaque con una mano de mortero. Añada el hielo, el Kahlua y el zumo de limón, introduzca la pajita y sirva inmediatamente.

5 cl di Kahlua
1 cucchiaio di zucchero di canna
1 limetta divisa in quattro
1 cl di succo di limone
Ghiaccio tritato
Cannuccia

Mettete la limetta e lo zucchero di canna in un bicchiere e schiacciate con un pestello. Versatevi sopra il ghiaccio tritato, il Kahlua e il succo di limone e servite subito con una cannuccia.

VINOdiVINO

Design: Lumír Berčík | Chef: Jiří Macek
Owner: Giancarlo Bertacchini

Vězeňská 3 | 110 00 Prague | Prague 1
Phone: +420 222 312 999
www.vinodivino.cz | vinodivino@vinodivino.cz
Subway: Staroměstská
Opening hours: Every day 11 am to 11 pm
Average price: Czk 500
Cuisine: Italian

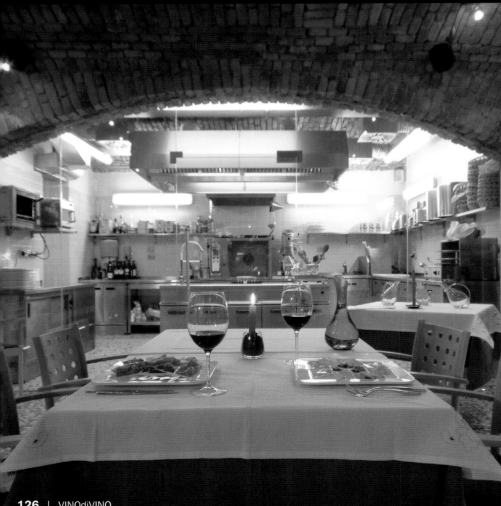

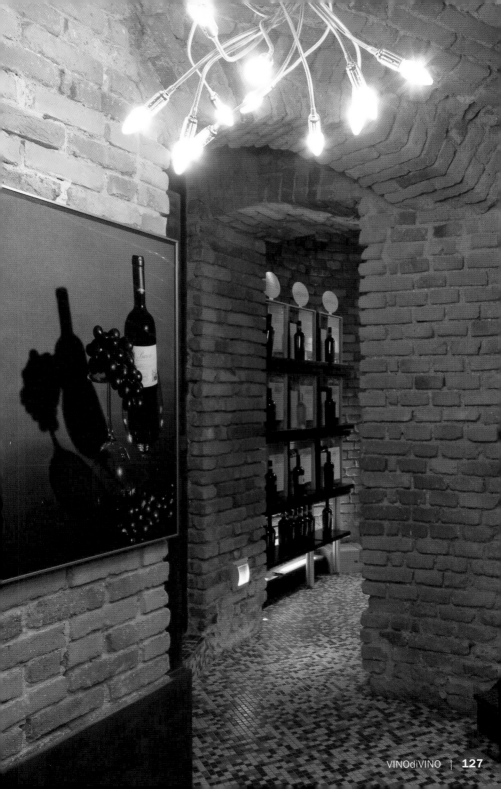

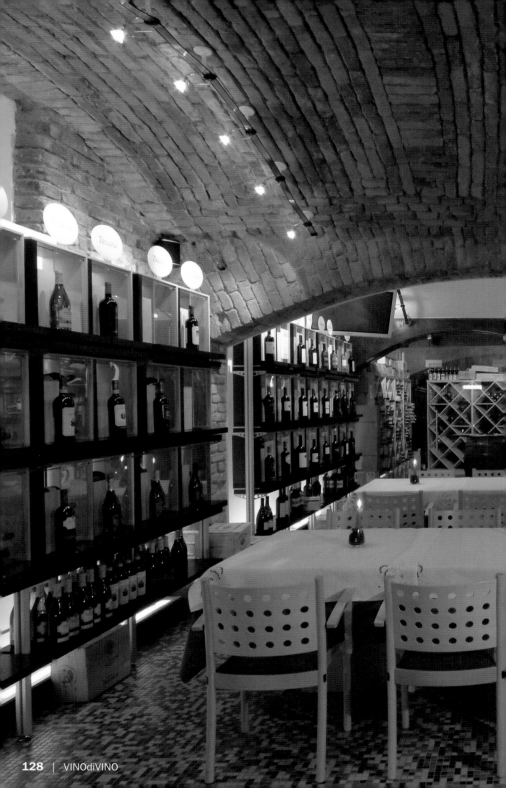

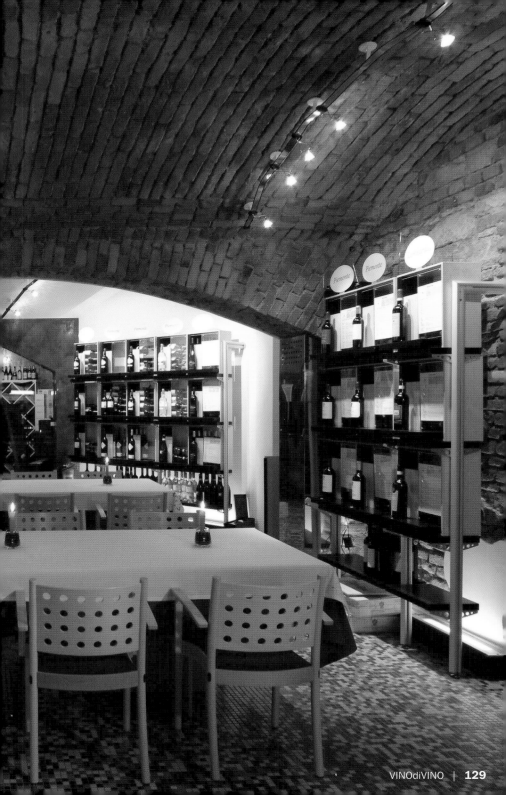

Zahrada V opere

Design: Bára Škorpilová, Mimolimit | Chef: Radek Příhonský
Owner: Daniel Jablonský

Legerova 75 | 110 00 Prague | Prague 1
Phone: +420 724 138 020
www.zahradavopere.cz | restaurant@zahradavopere.cz
Subway: I. P. Pavlova
Opening hours: Every day 11:30 am to 1 am, kitchen till midnight
Average price: Czk 700
Cuisine: International
Special features: Catering

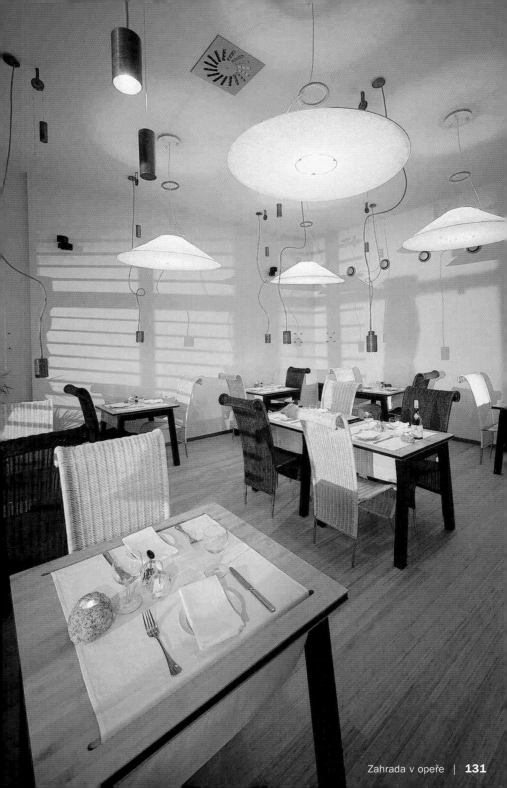

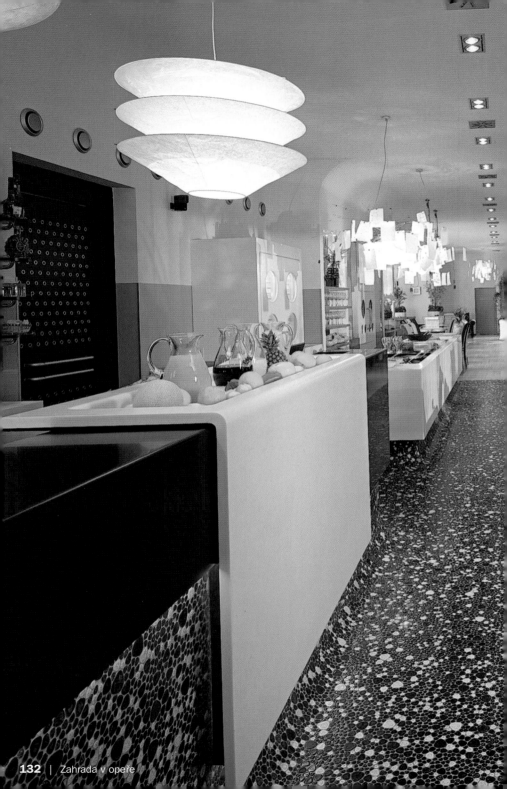

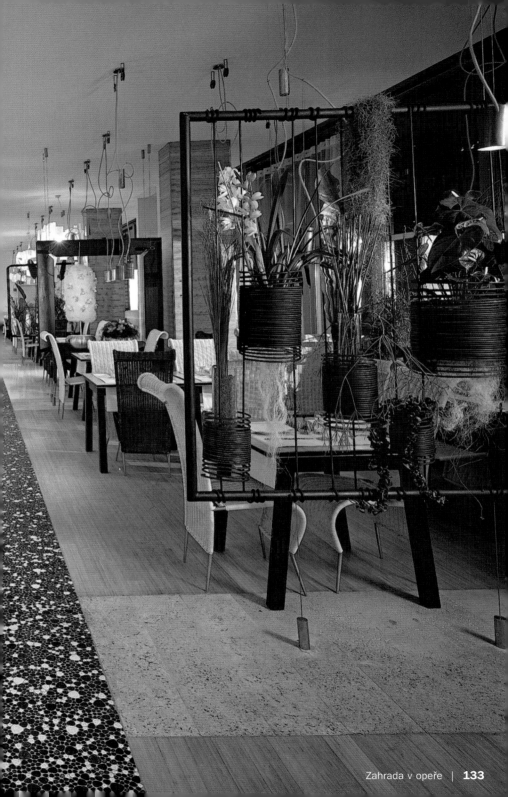

No.	Restaurant	Page

Letenské Sady

Hradčany

22

Mánesův m

3

21

8

12

Karlův most

Petřinské Sady

Vítežná

most Legií

Jiráskův m

Palackého mo

Cool Restaurants

Size: 14 x 21.5 cm / 5 $\frac{1}{2}$ x 8 $\frac{1}{2}$ in.
136 pp
Flexicover
c. 130 color photographs
Text in English, German, French,
Spanish and (*) Italian / (**) Dutch

Other titles in the same series:

Amsterdam (*)
ISBN 3-8238-4588-8

Barcelona (*)
ISBN 3-8238-4586-1

Berlin (*)
ISBN 3-8238-4585-3

Brussels (**)
ISBN 3-8327-9065-9

Chicago (*)
ISBN 3-8327-9018-7

Côte d'Azur (*)
ISBN 3-8327-9040-3

Hamburg (*)
ISBN 3-8238-4599-3

London
ISBN 3-8238-4568-3

Los Angeles (*)
ISBN 3-8238-4589-6

Madrid (*)
ISBN 3-8327-9029-2

Miami (*)
ISBN 3-8327-9066-7

Milan (*)
ISBN 3-8238-4587-X

Munich (*)
ISBN 3-8327-9019-5

New York
ISBN 3-8238-4571-3

Paris
ISBN 3-8238-4570-5

Rome (*)
ISBN 3-8327-9028-4

San Francisco
ISBN 3-8327-9067-5

Shanghai (*)
ISBN 3-8327-9050-0

Sydney (*)
ISBN 3-8327-9027-6

Tokyo (*)
ISBN 3-8238-4590-X

Vienna (*)
ISBN 3-8327-9020-9

Zurich (*)
ISBN 3-8327-9069-1

To be published in the same series:

Cape Town
Copenhagen
Dubai
Geneva
Hong Kong
Ibiza/Majorca
Istanbul

Las Vegas
Mexico City
Moscow
Singapore
Stockholm
Toscana

teNeues